cute kawaii coloring

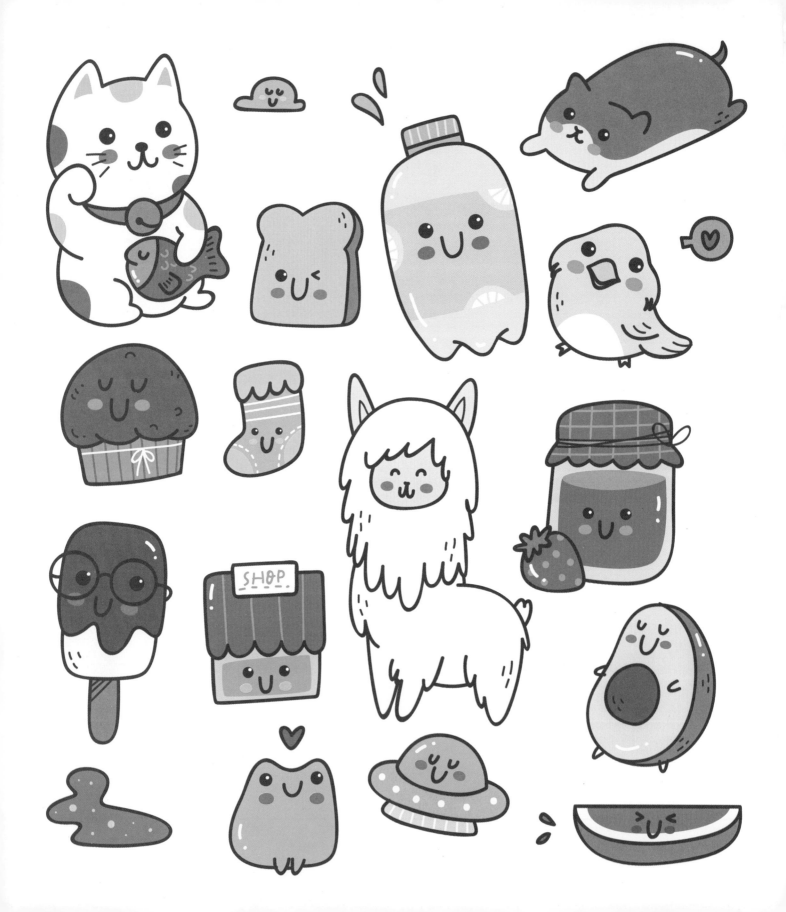

Cute Kawaii Coloring

Color Super-Cute Cats, Sushi, Clouds, Flowers, Monsters, Sweets, and More!

chartwell
books

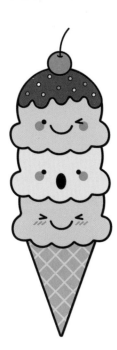

The Wonderful World of Kawaii

Are you in need of an extra dose of cuteness? Do you find yourself needing some creative inspiration? Look no further because *Cute Kawaii Coloring* is the most adorable excuse to spend time with yourself as you fill these pages with every color imaginable.

Kawaii is a Japanese term that roughly translates to "cute" in English, though "kawaii" is more of a concept. It can be used to describe people, clothes, characters and even handwriting. If you're a fan of Hello Kitty or Pusheen the Cat, then you're already familiar with the kawaii universe. Discover new kawaii doodles with over 50 coloring templates to bring to life, from happy sushi rolls to the cuddliest kittens.

There are no rules to how you want to color these adorable friends. You can use fun neon colors when you're feeling bright and excited, or traditional primary colors when you want to take it back to basics. Explore all types of creativity—color outside

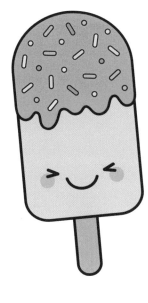

the lines, or choose to make a purple cat. After all, these pages are filled with donuts that have little smiles and the cutest imaginary creatures...everything is possible!

Whether you need a break to de-stress and relax, or you just need a fun activity to pass the time, all ages will be captivated by the adorable doodles in this fun coloring book. The act of coloring can be meditative in and of itself, bringing stress relief just through the simple act of picking up a colored pencil or crayon and focusing creativity and thoughts on a single coloring exercise.

The great thing about coloring is that it's fun for everybody, regardless of artistic experience! With coloring pages that have kittens, food, plants and nature, and adorably mischievous monsters you're sure to find the perfect kawaii character for you. So, dive in and take a tour of the wonderful world of kawaii art.

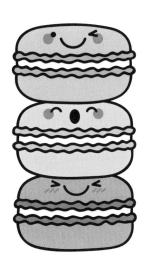

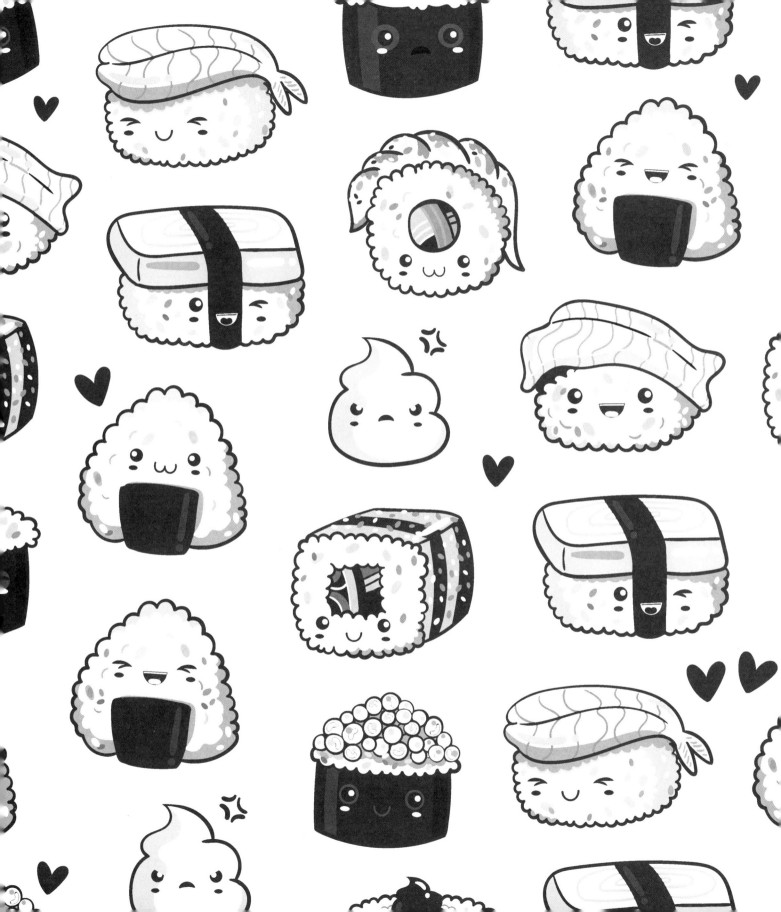

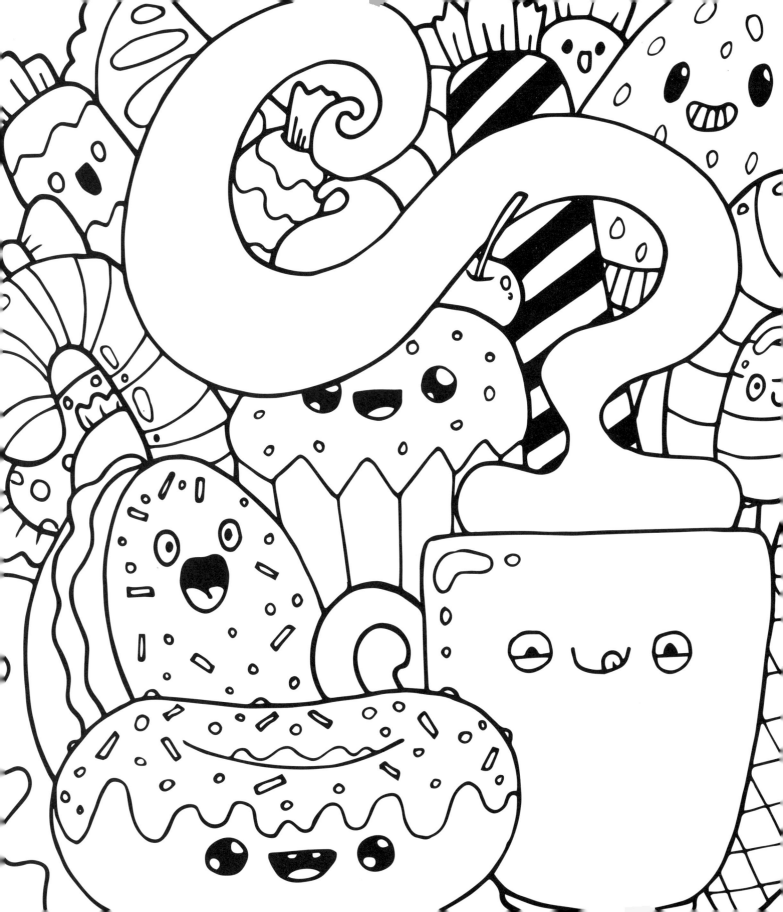

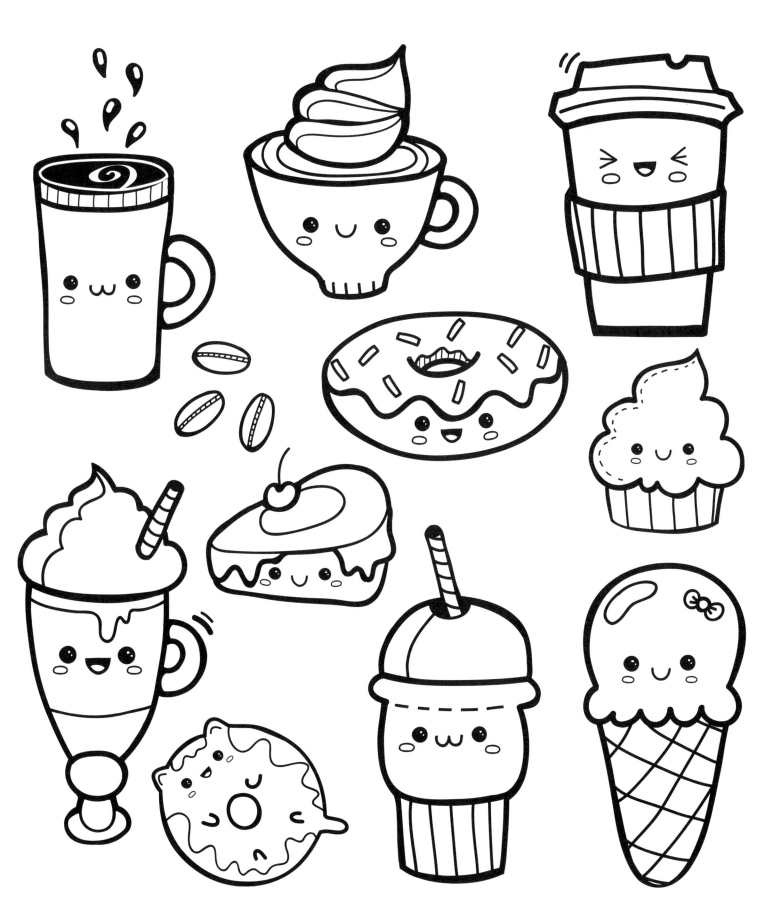

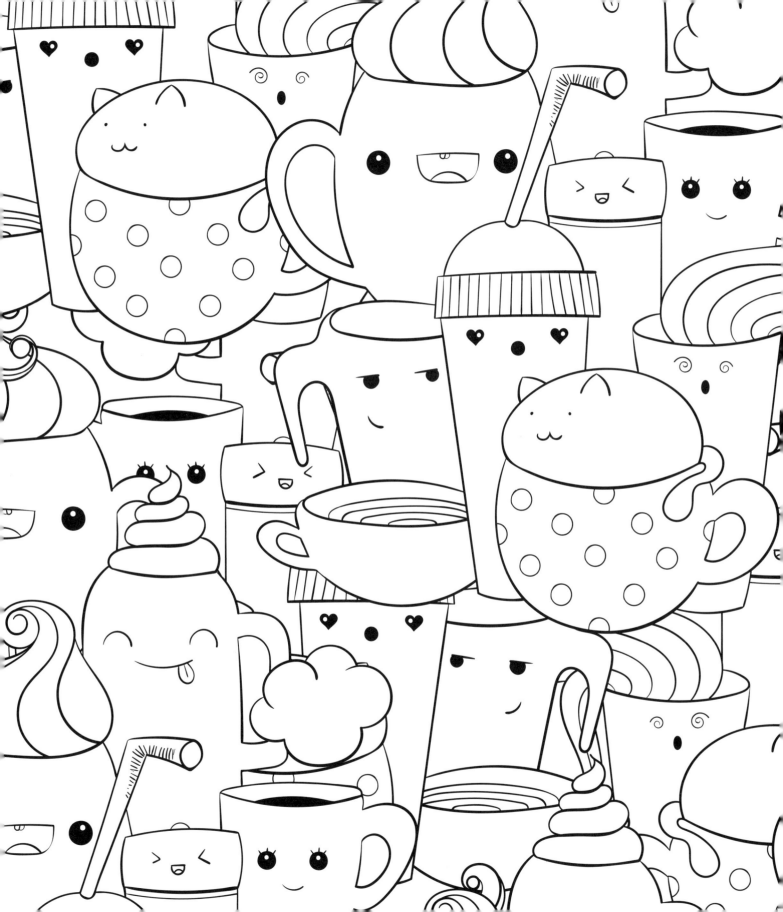

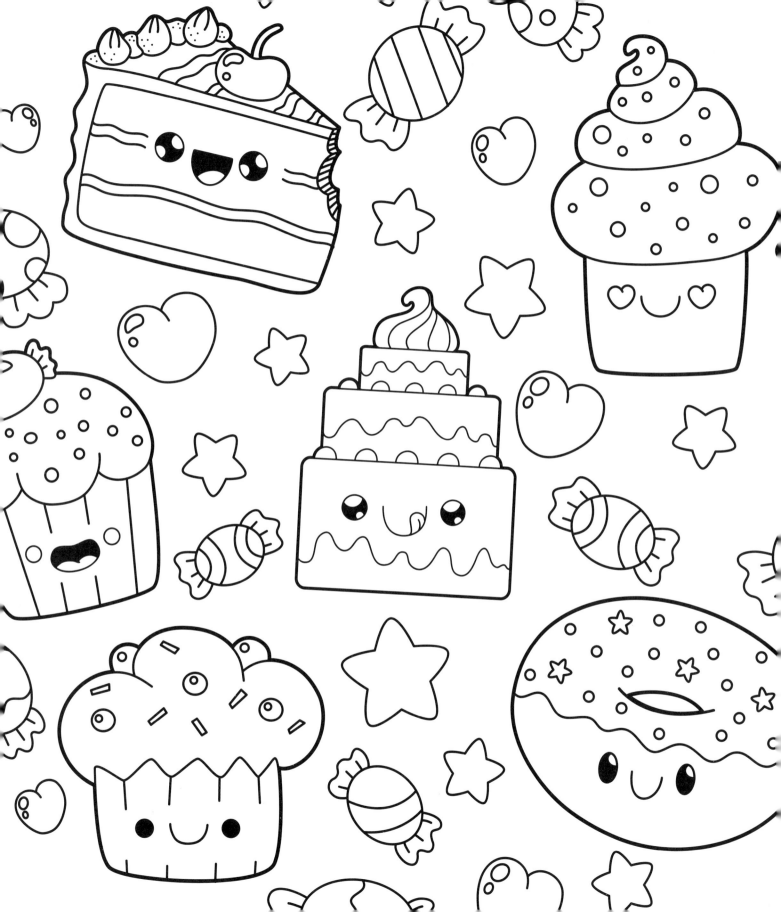

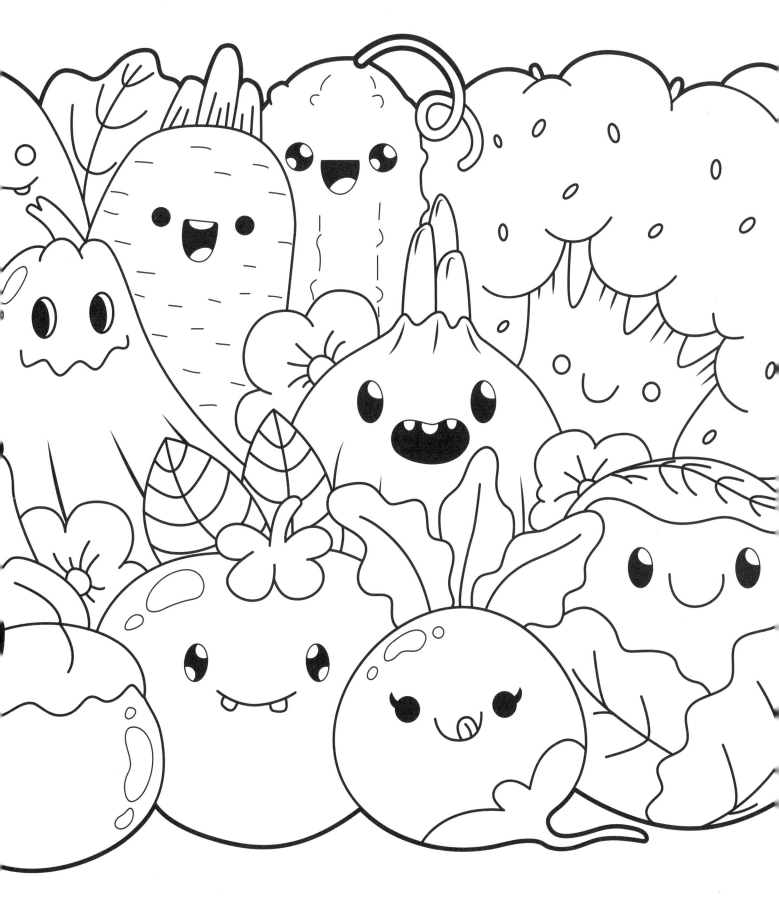

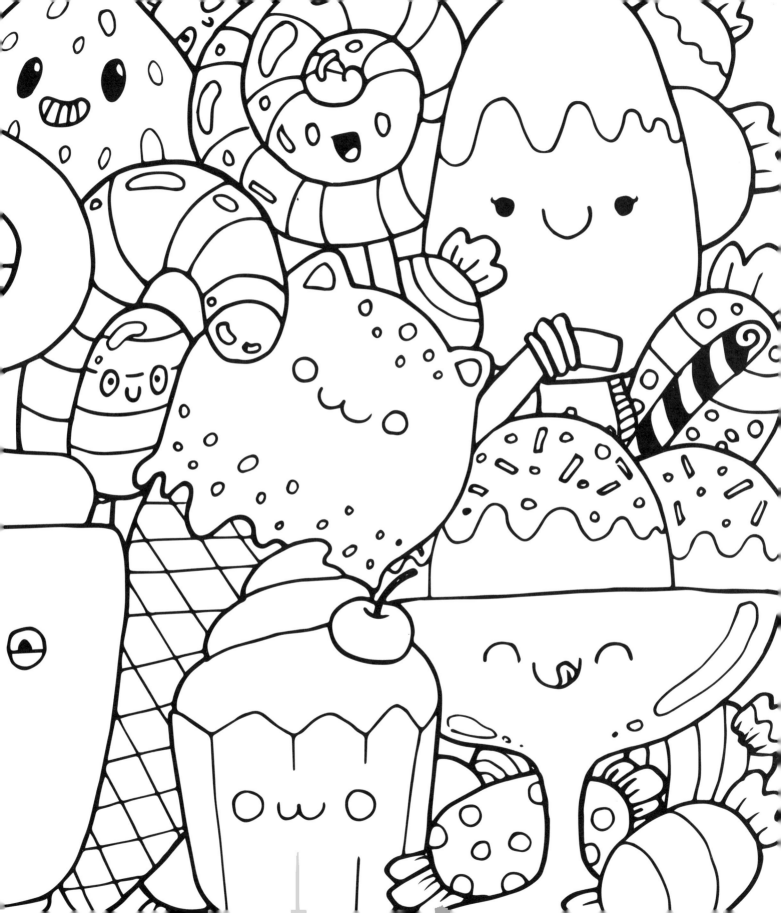

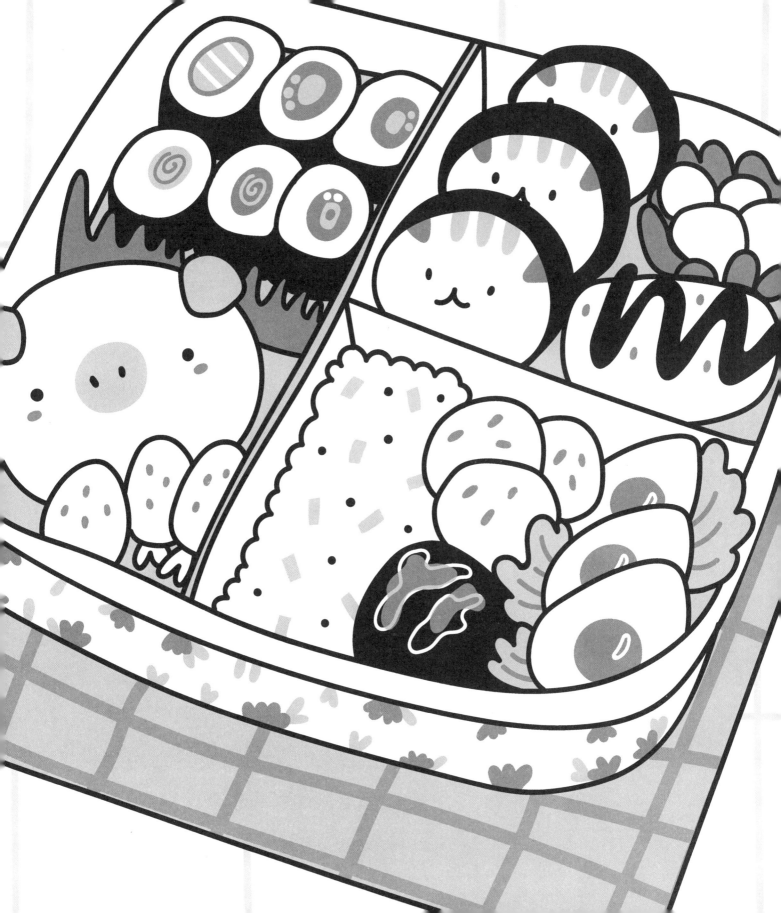

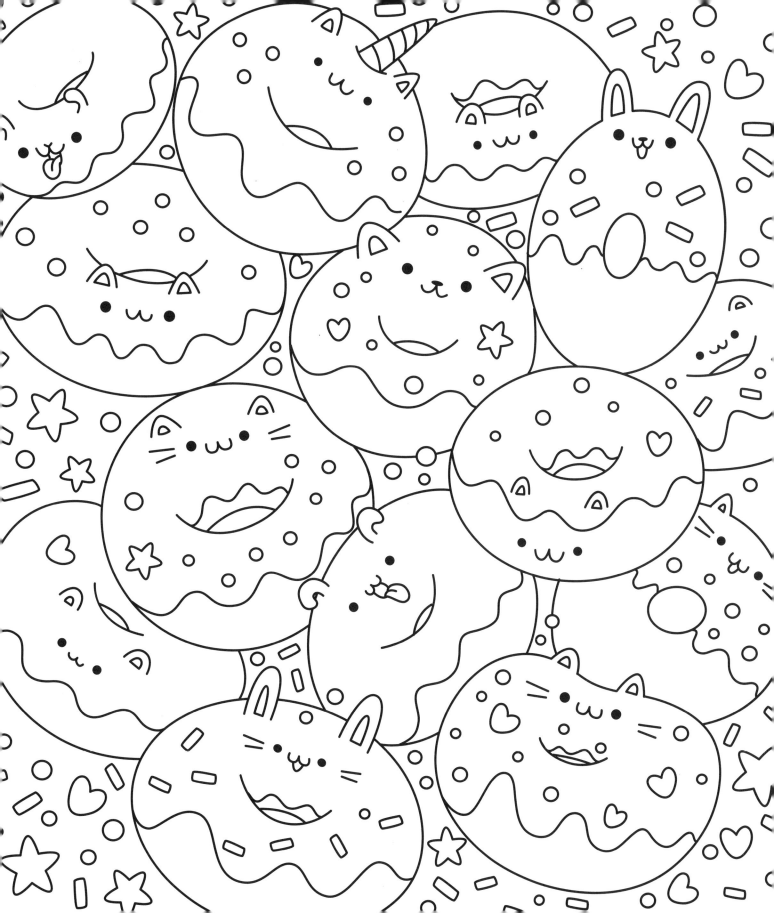

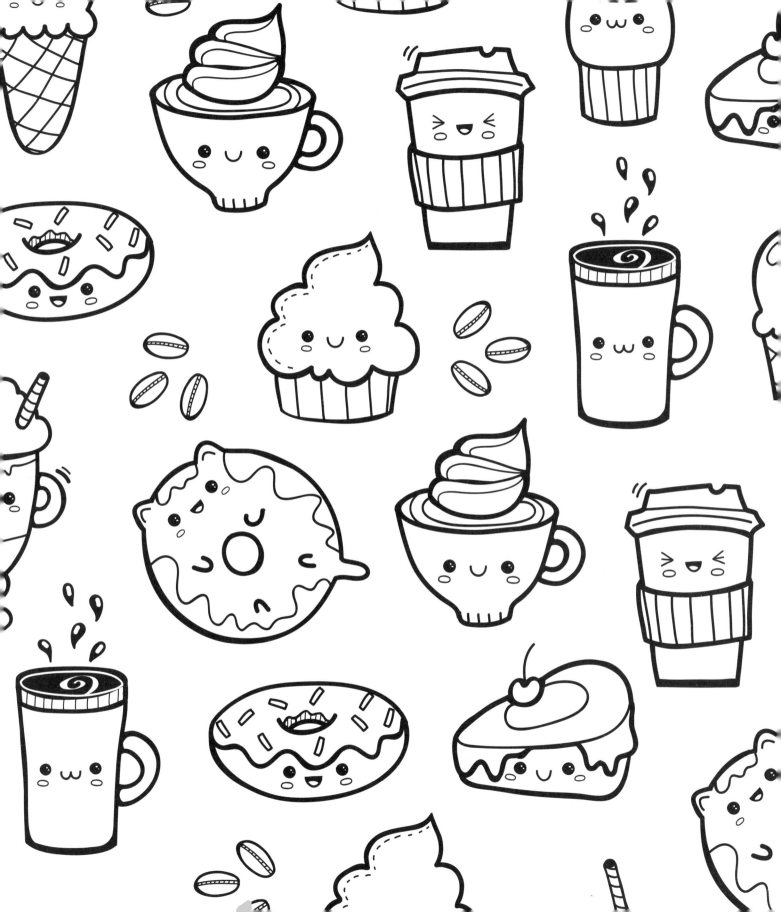

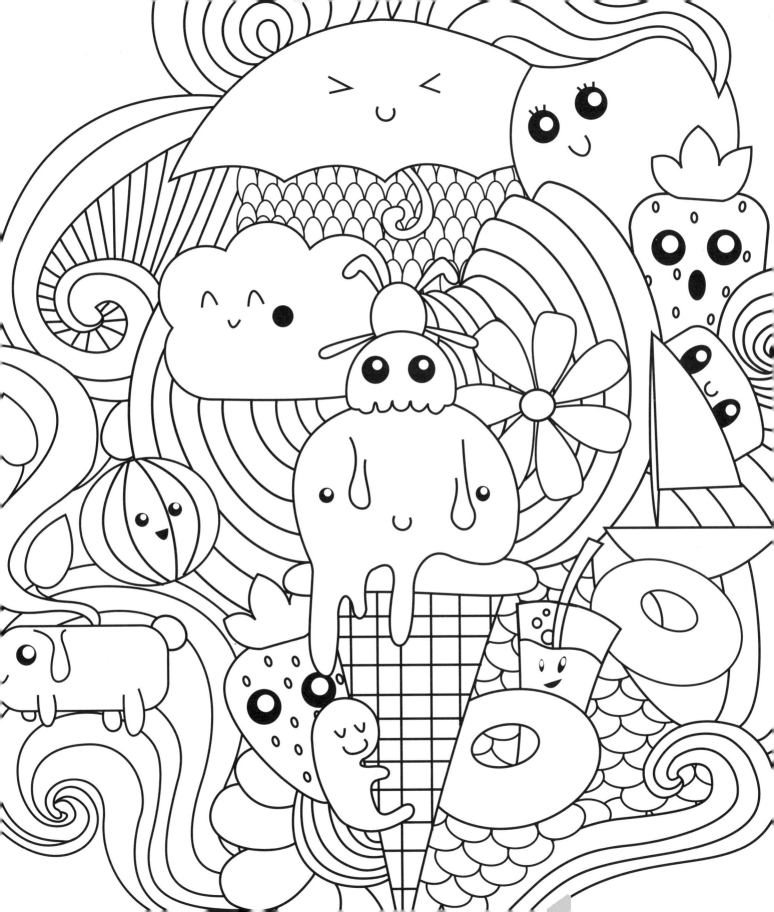

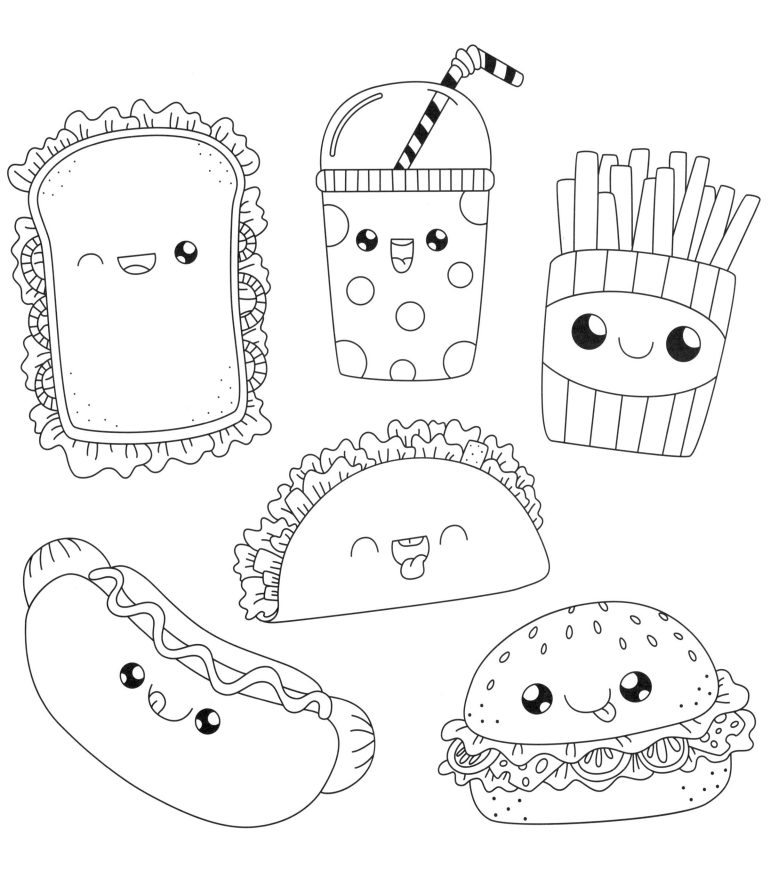

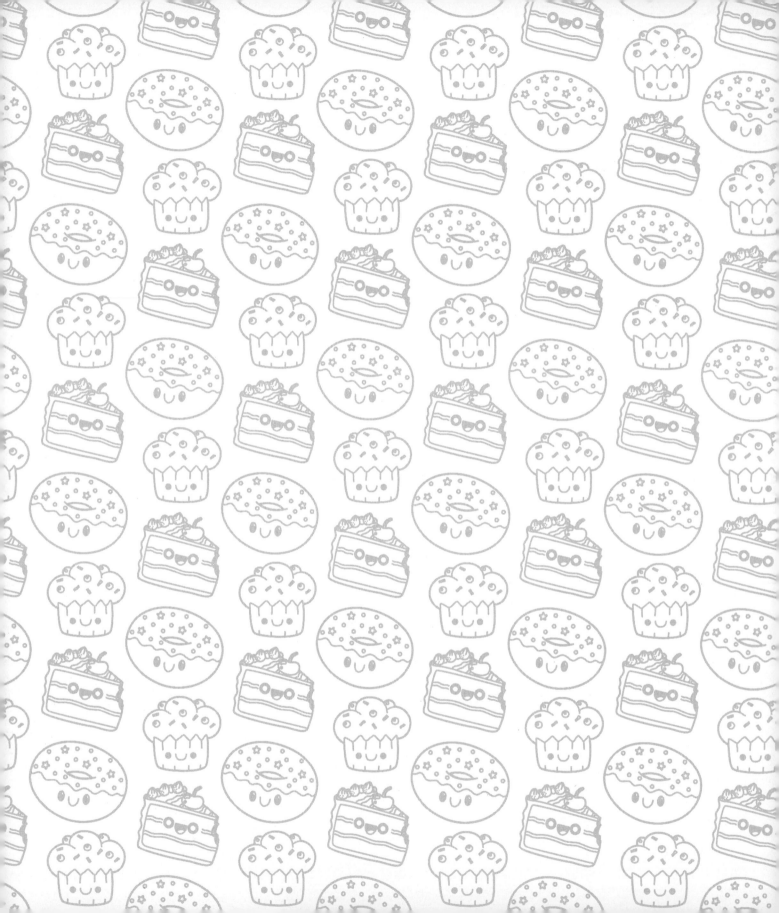

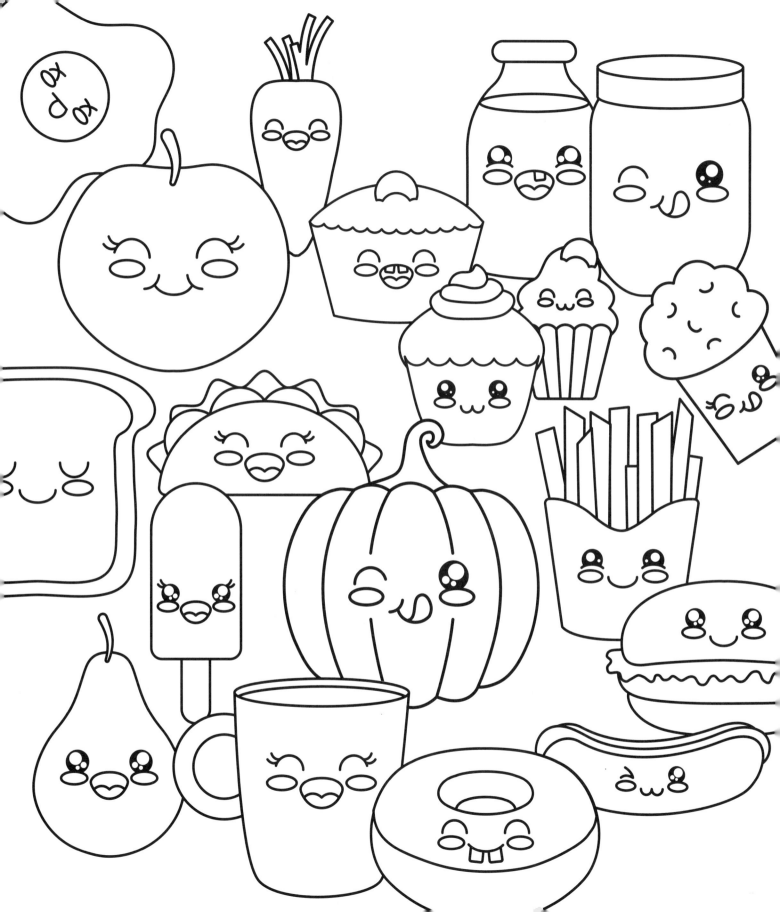

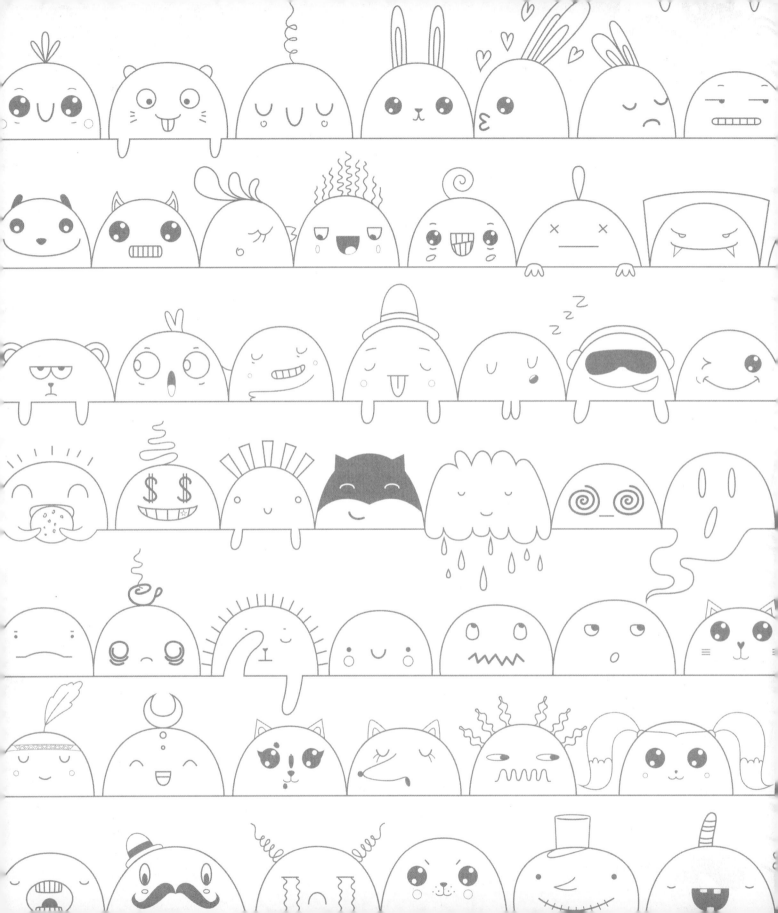

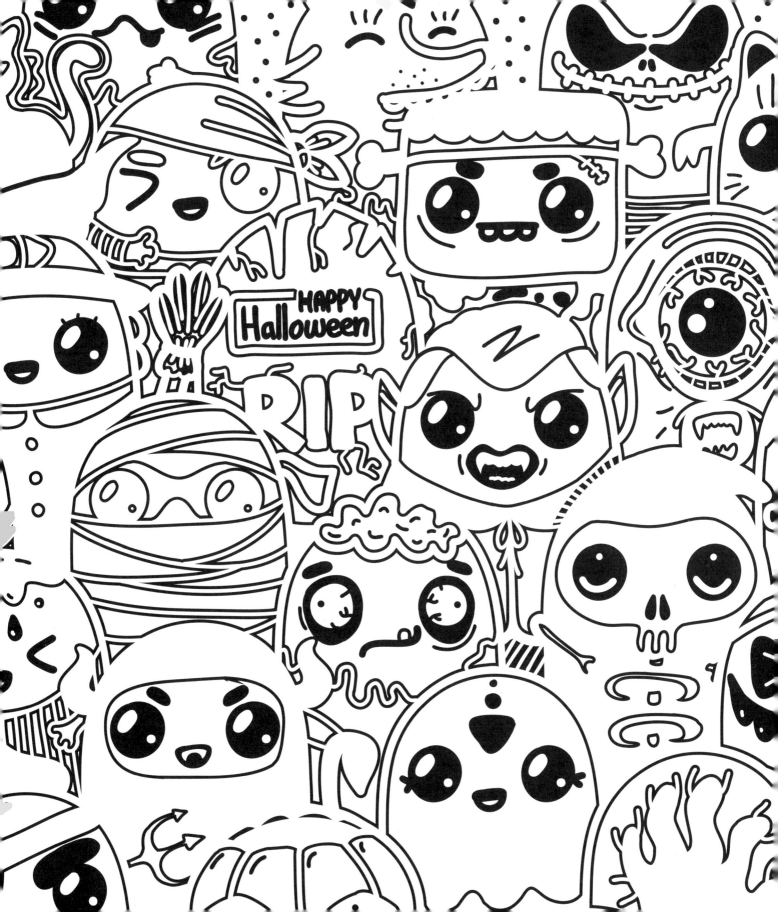

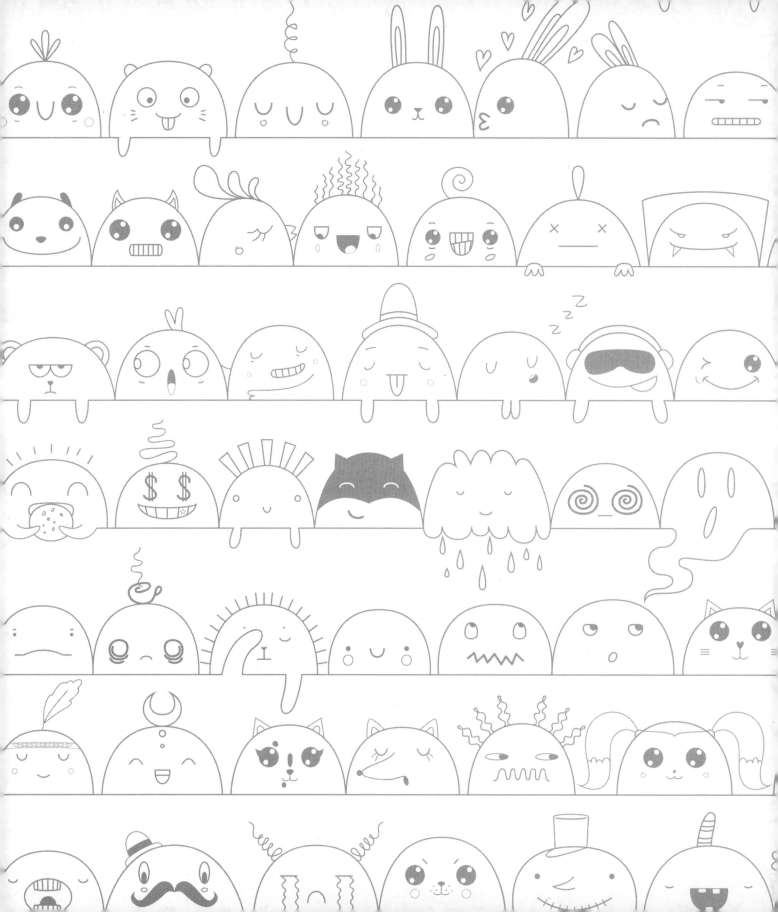

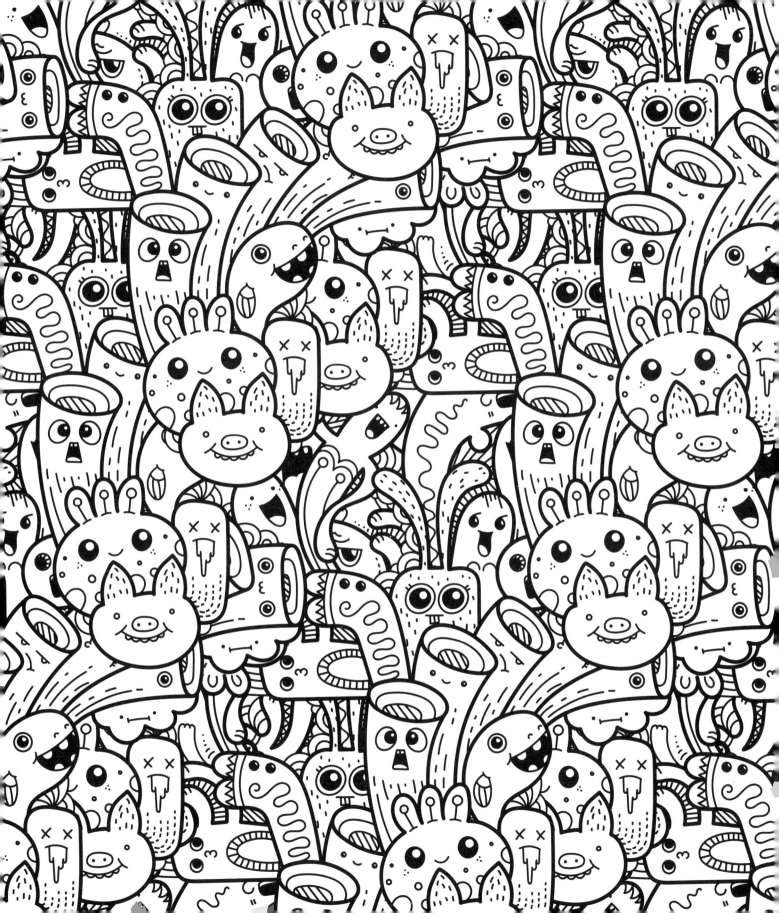

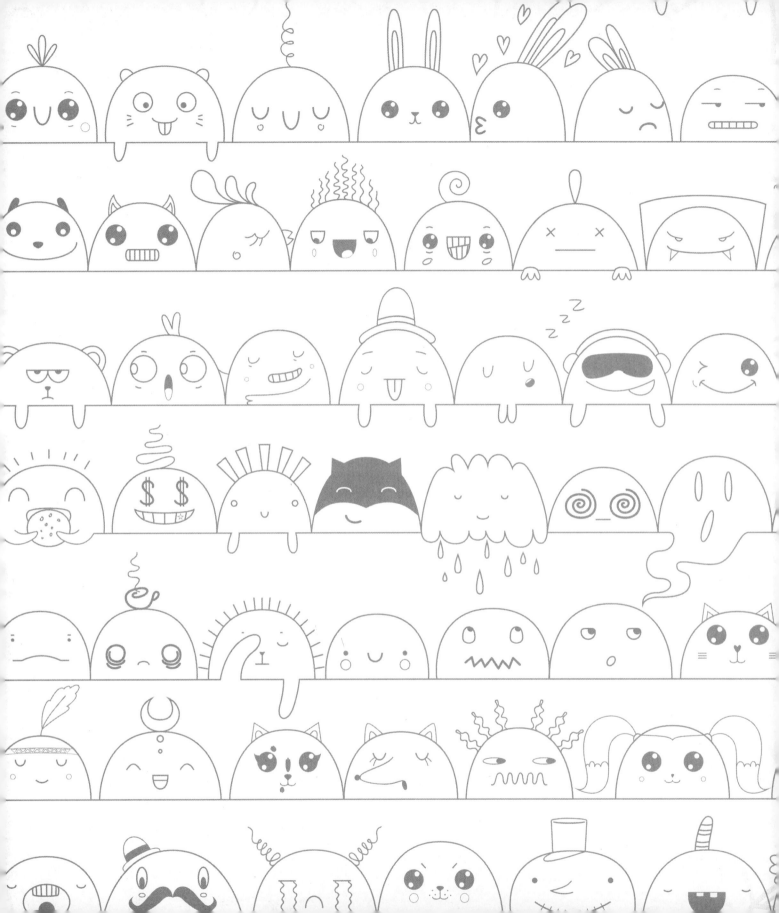

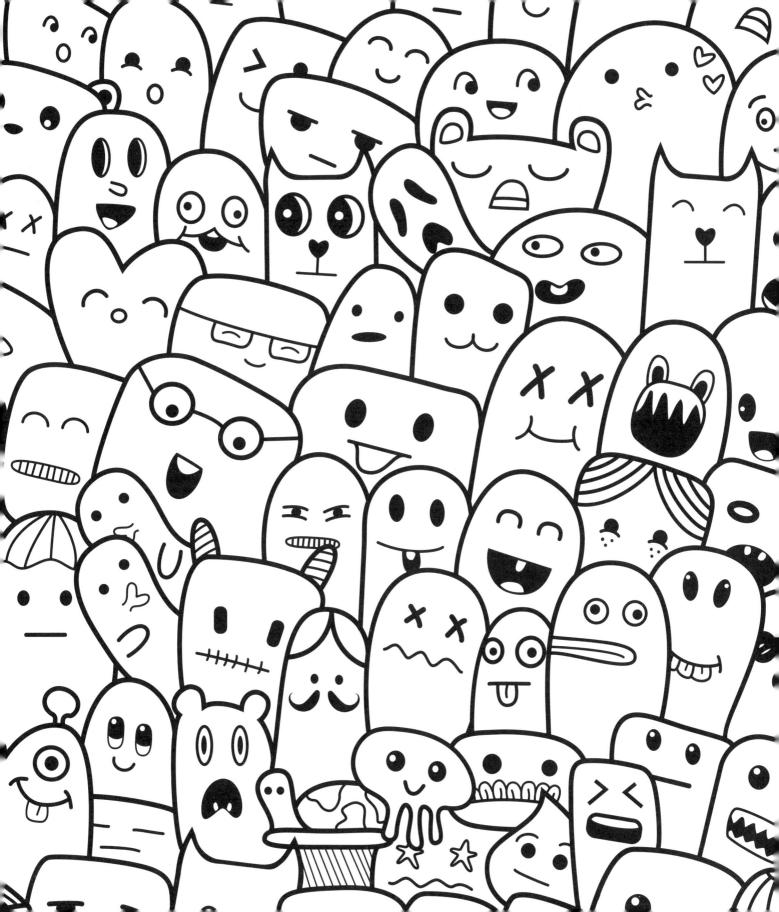

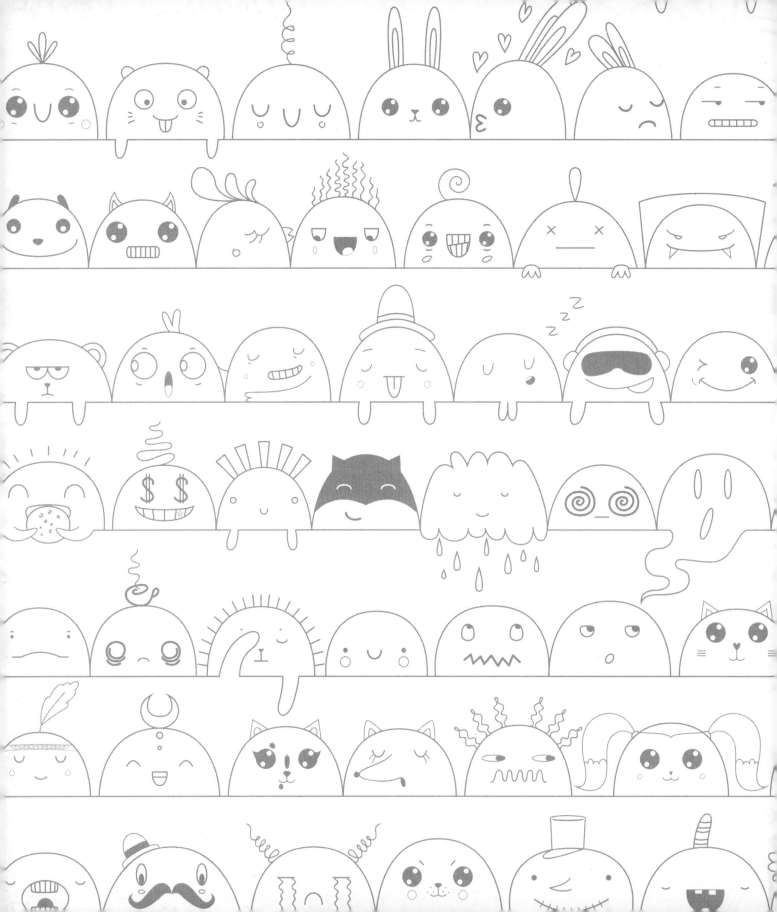

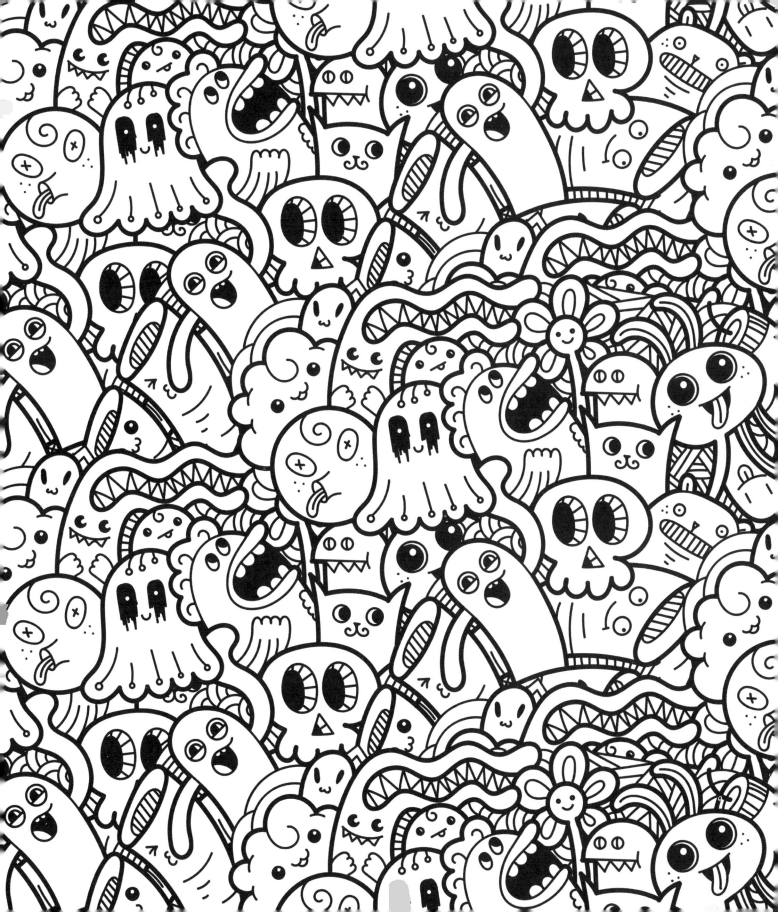

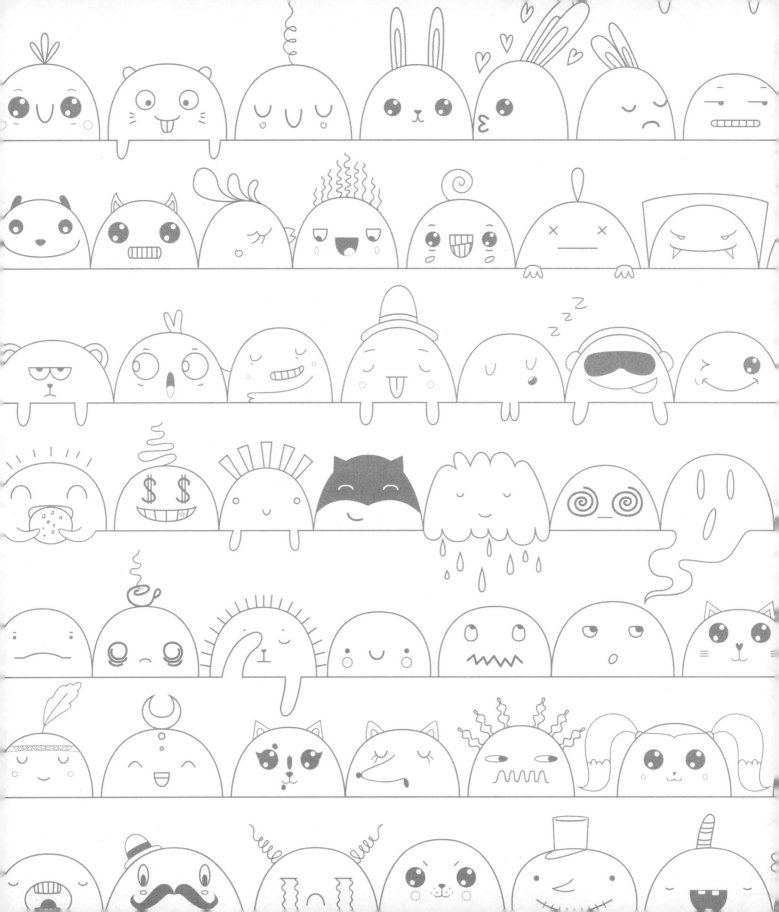

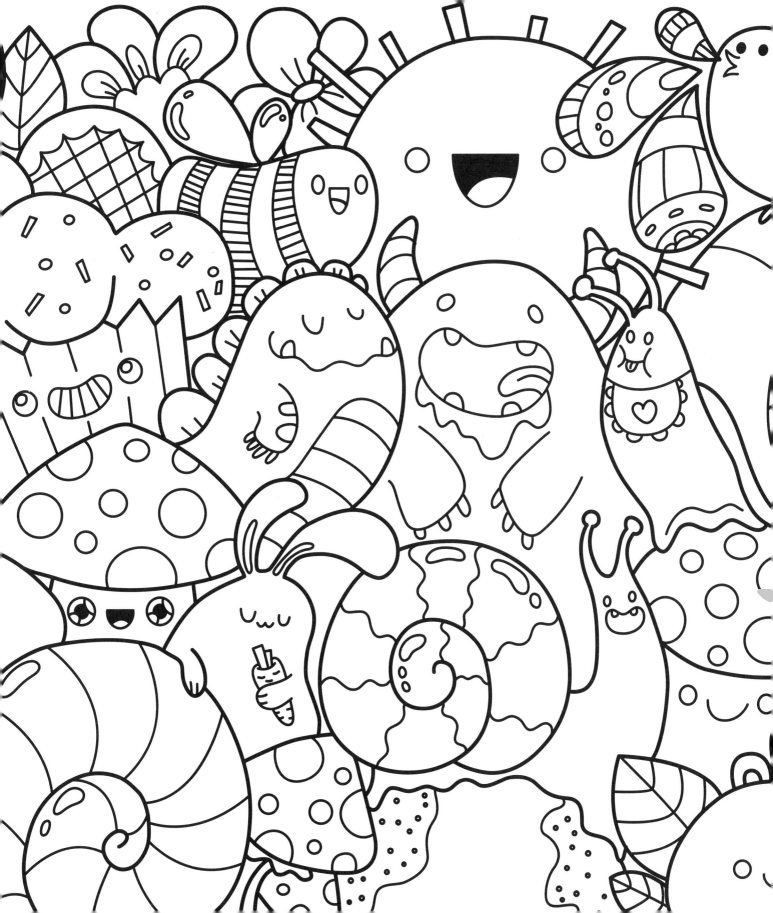

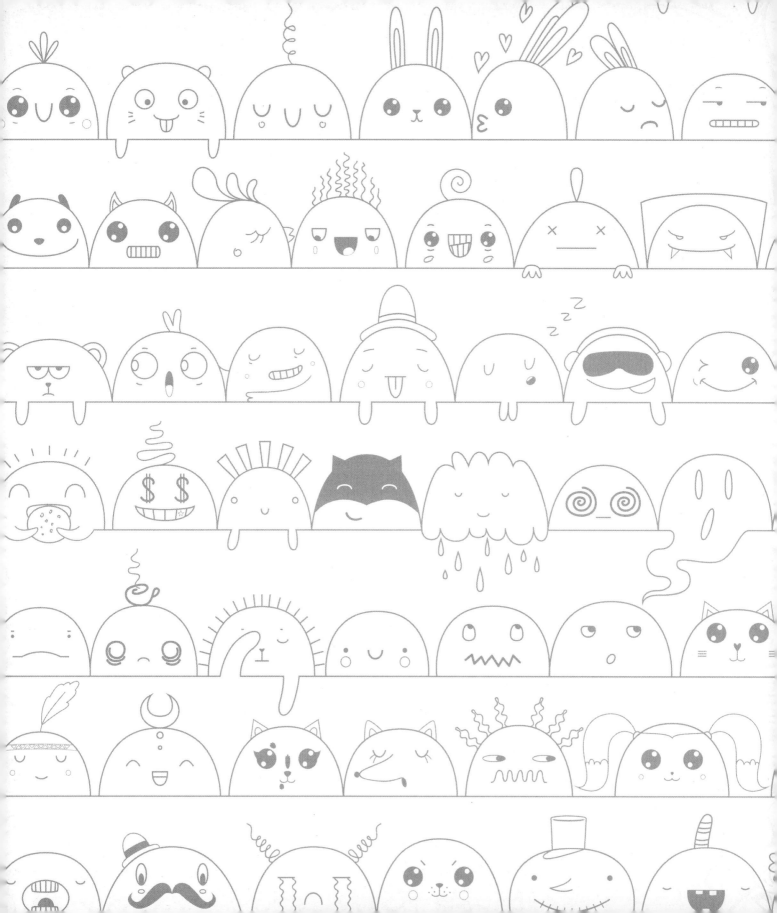

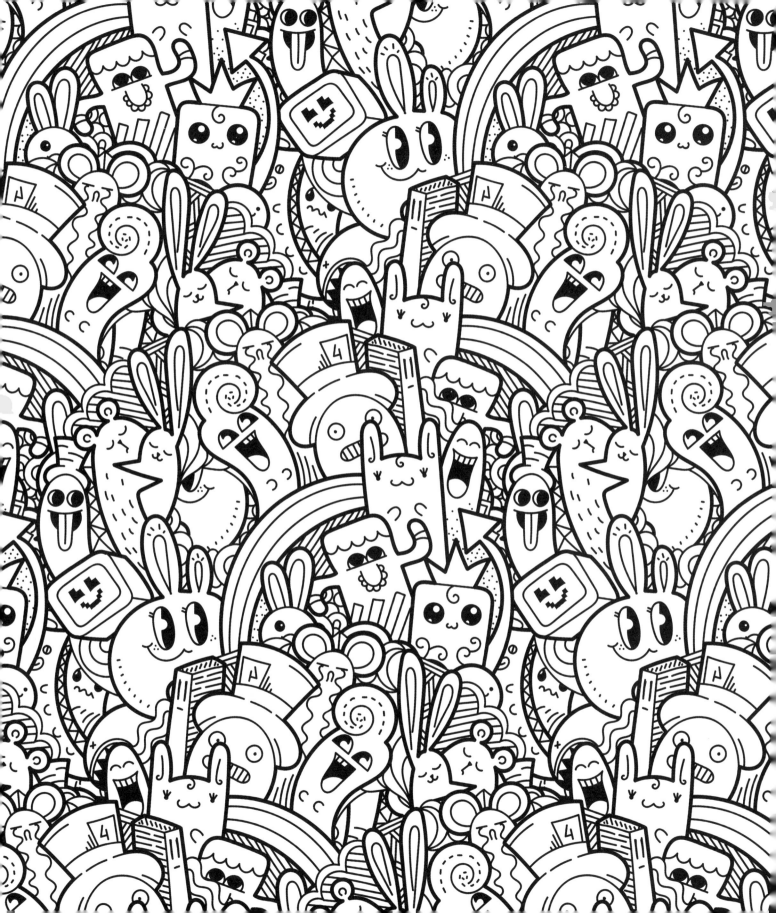

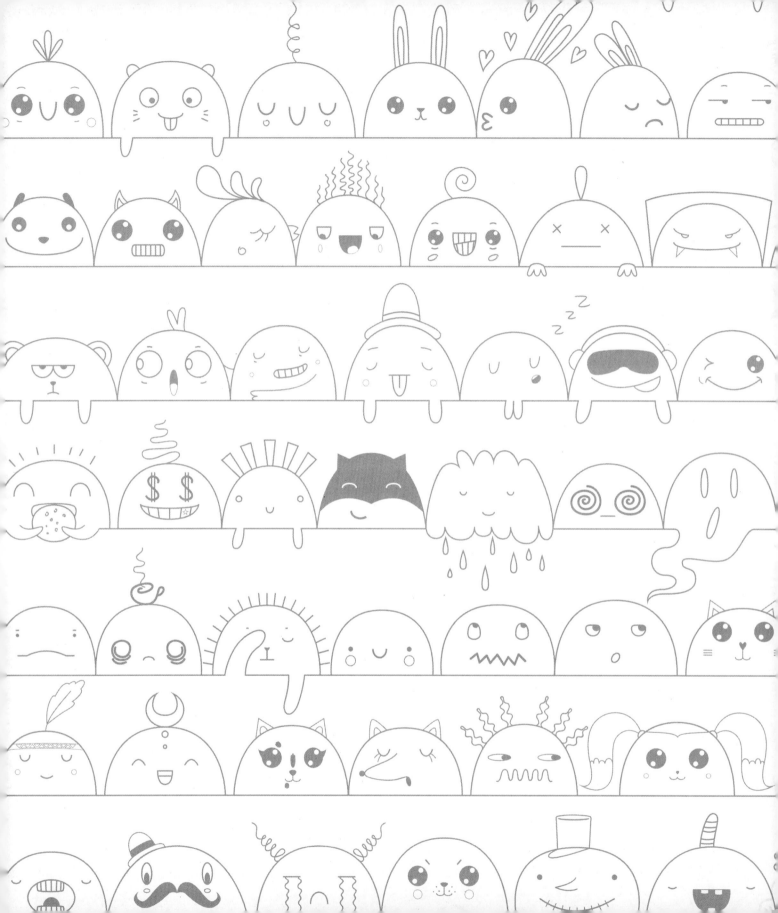

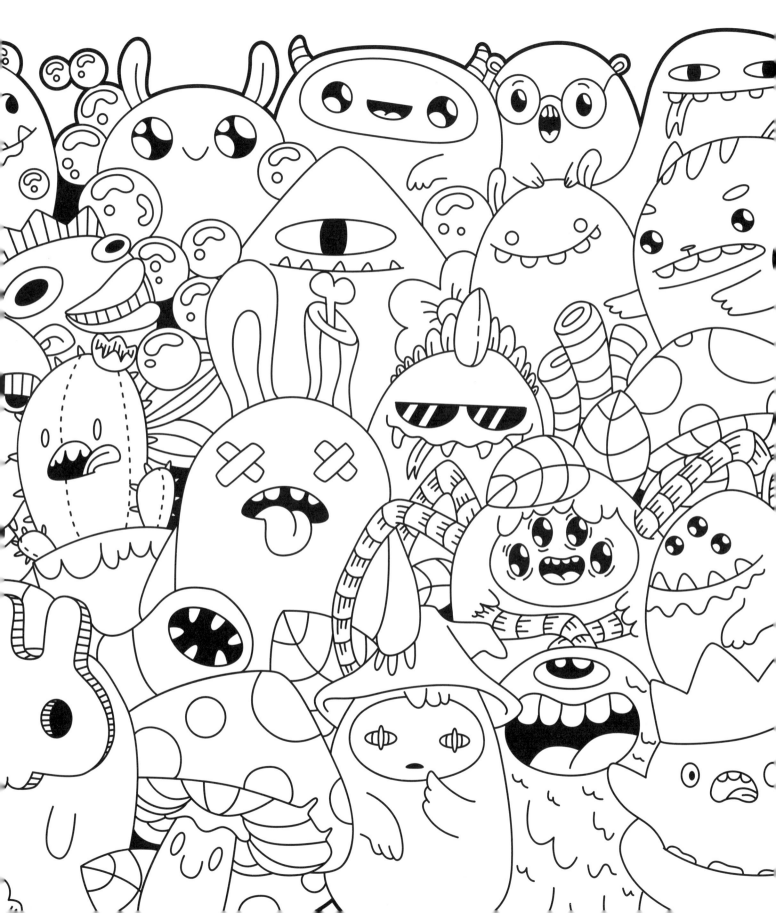

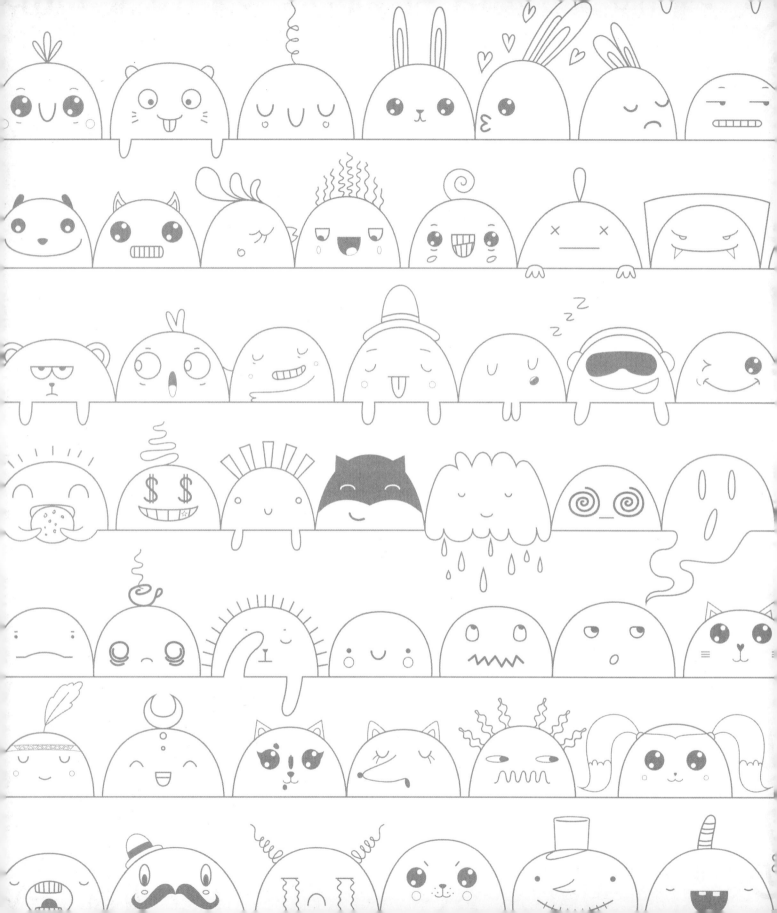

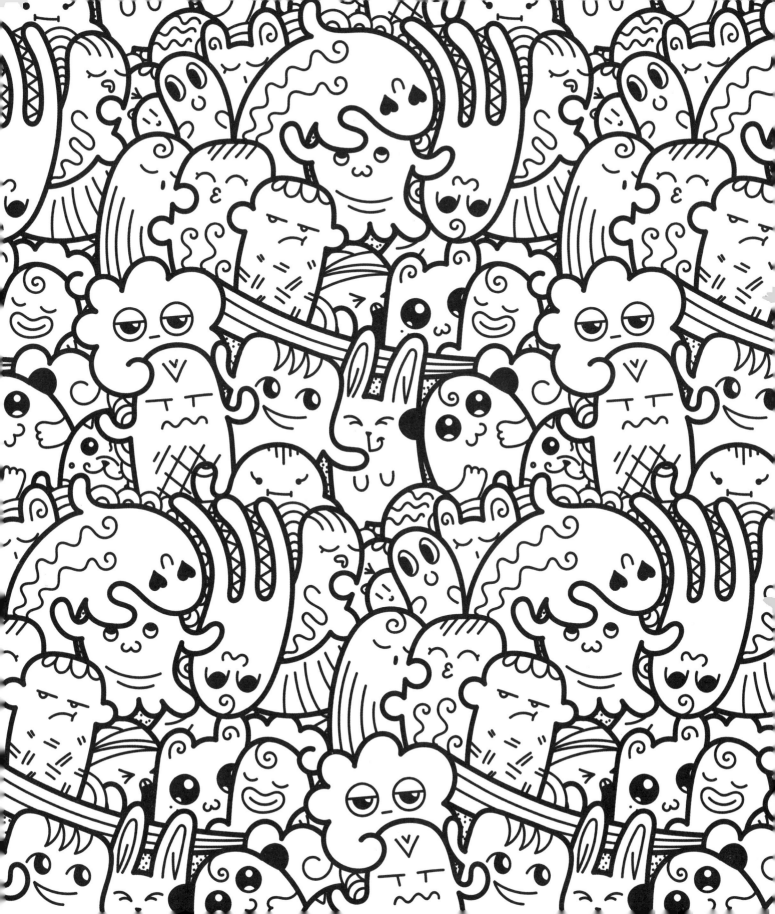

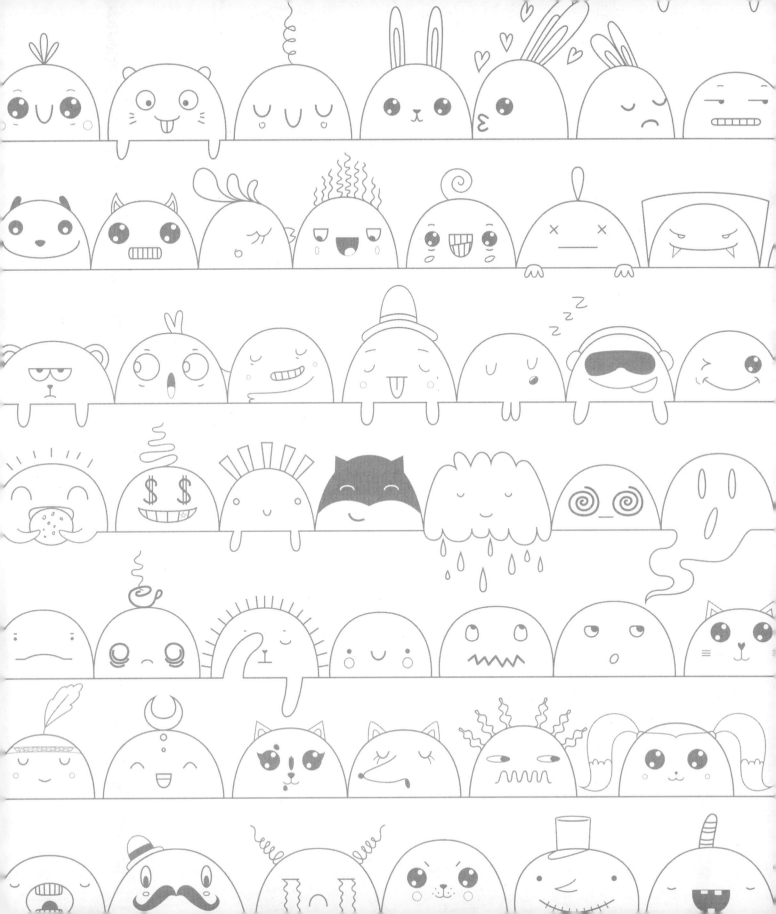

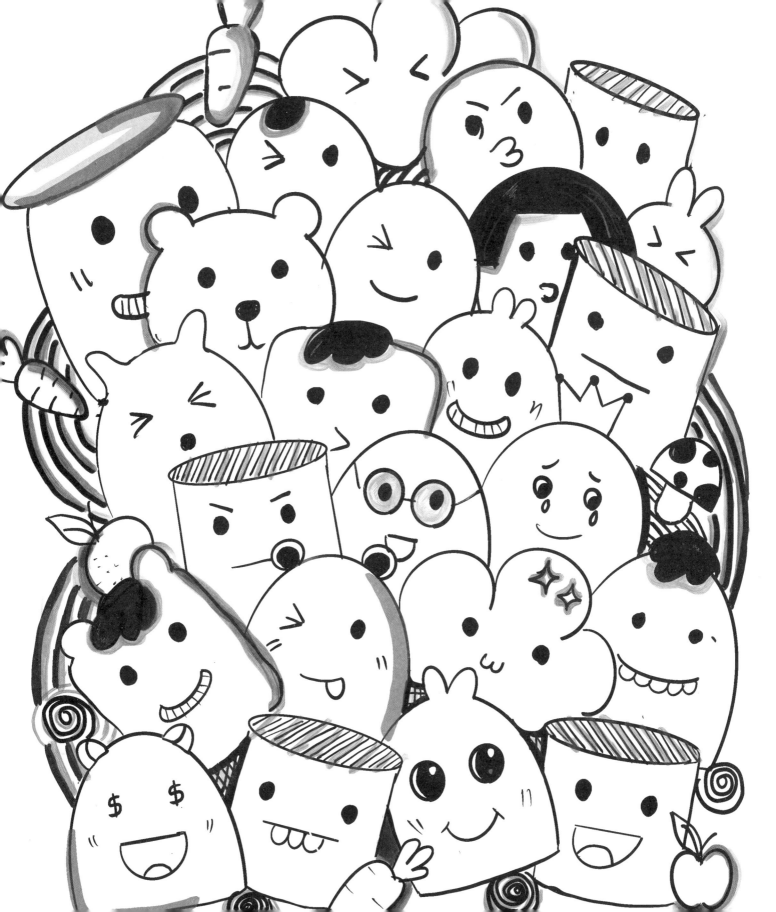

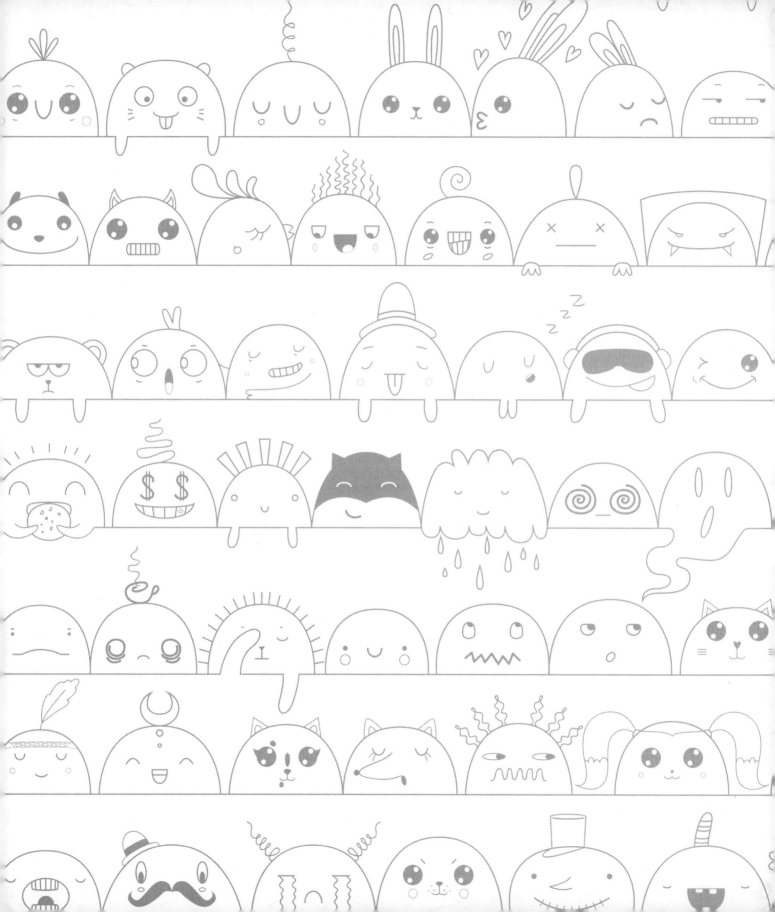

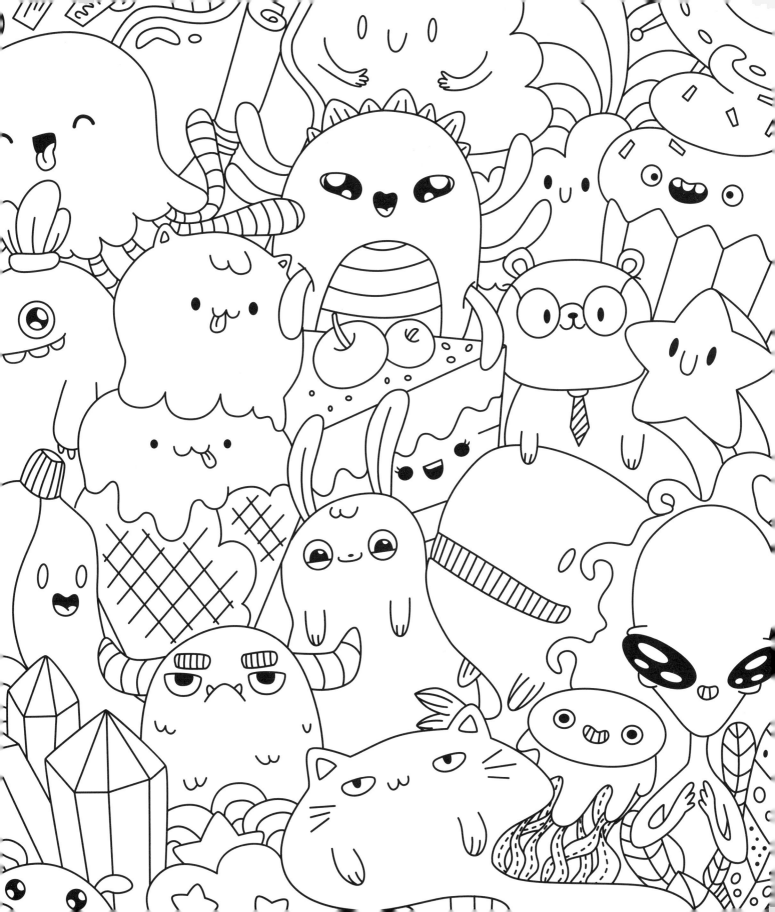

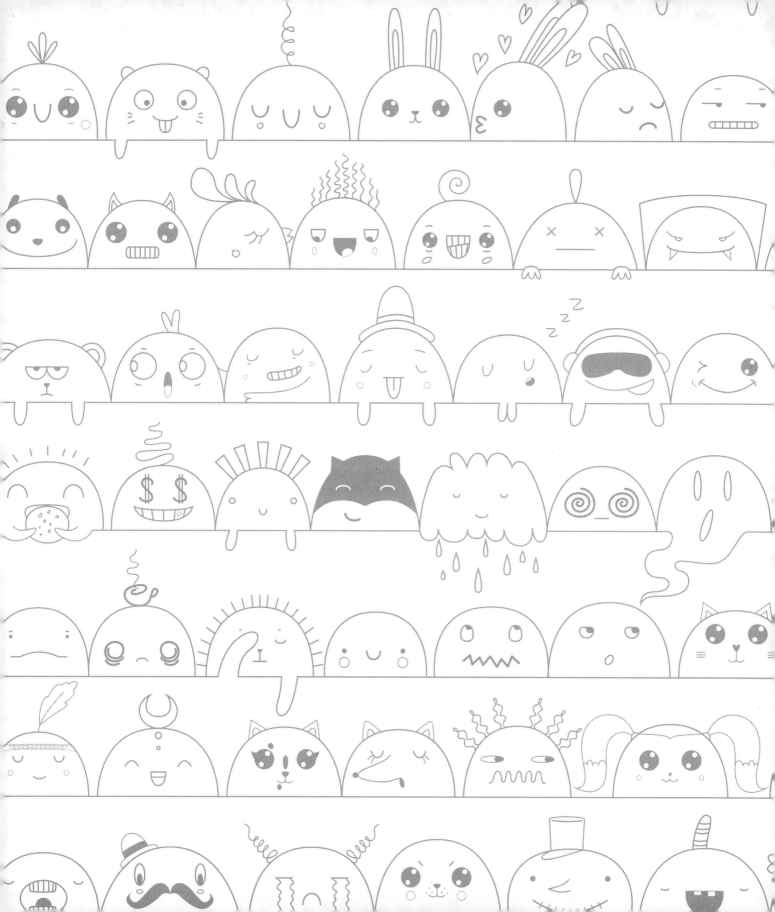

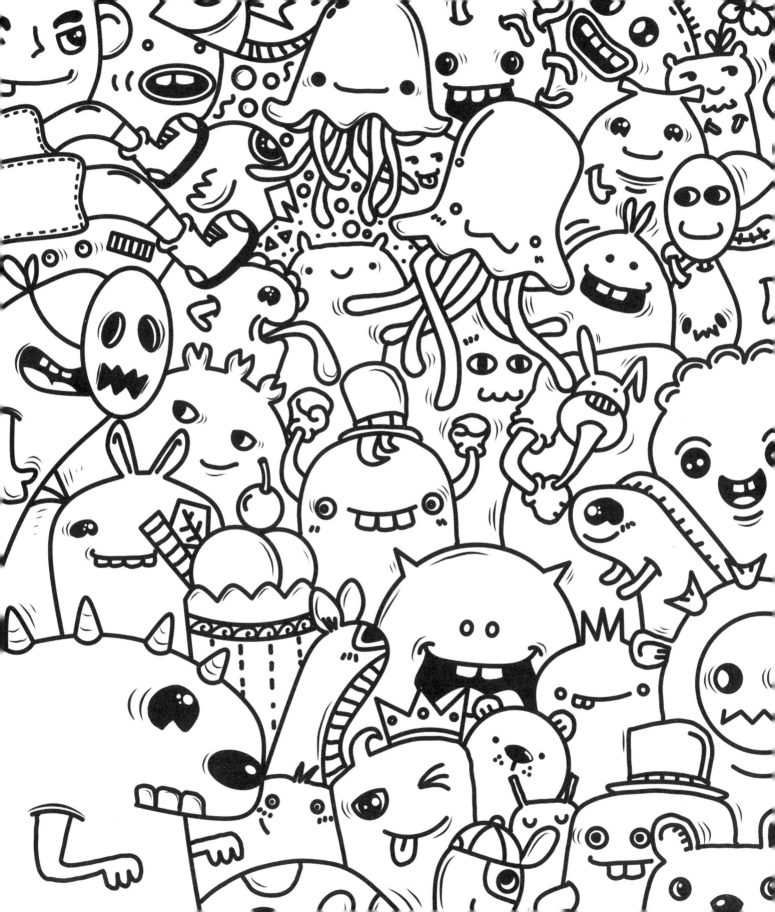

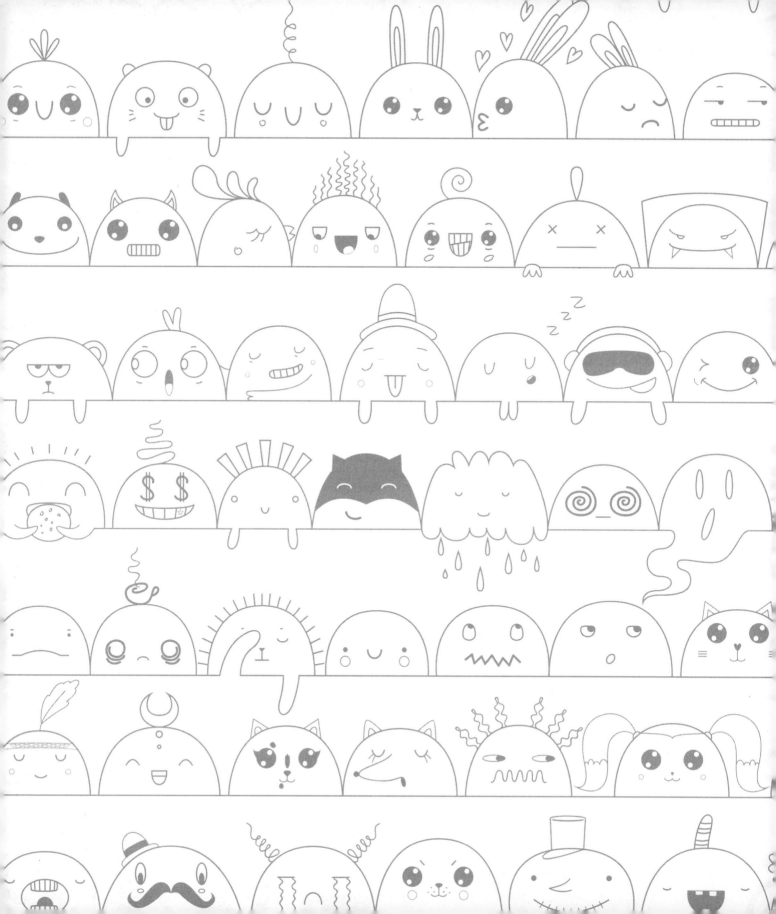

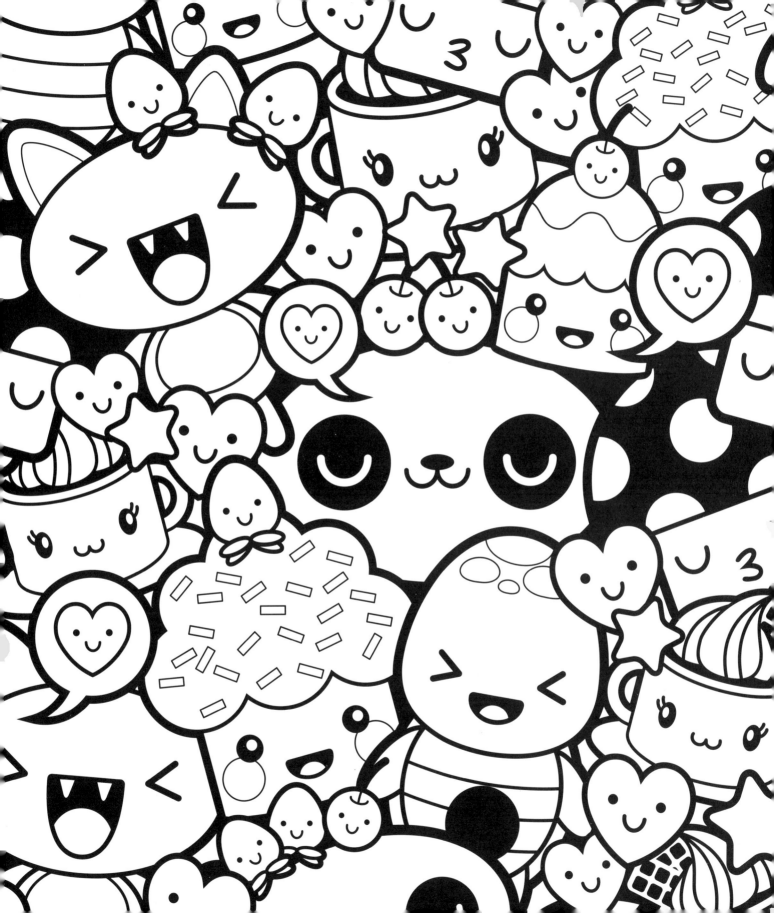

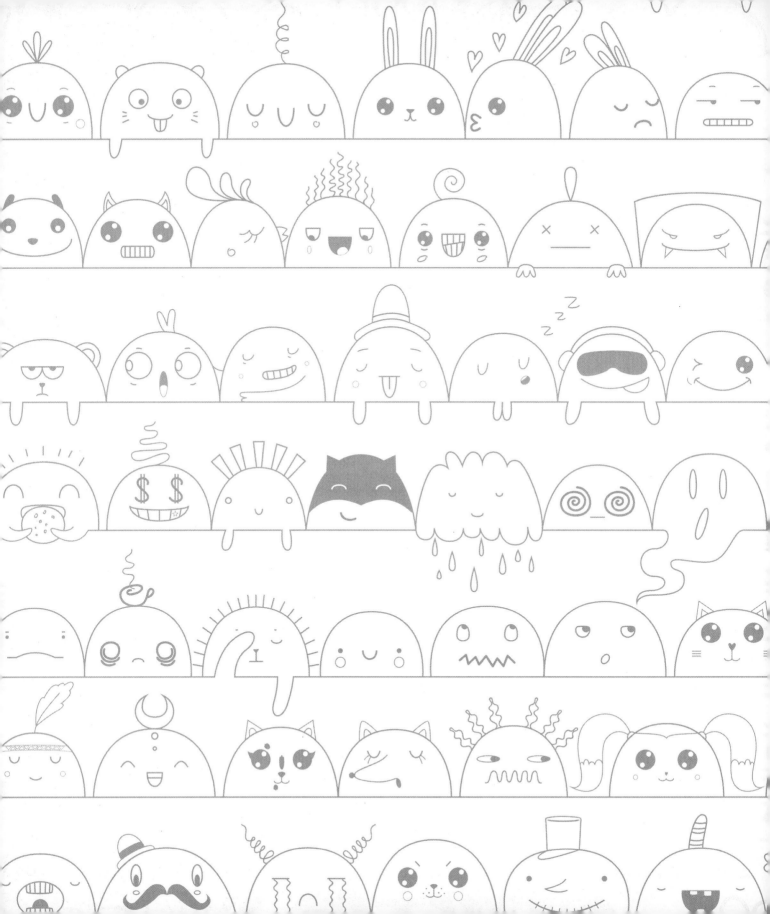

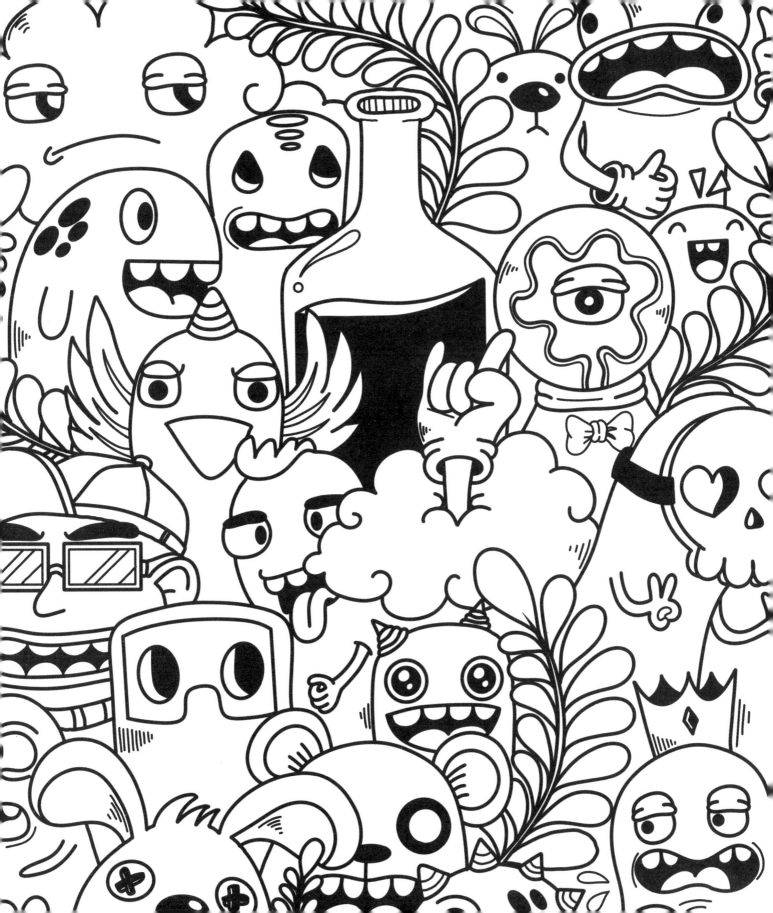

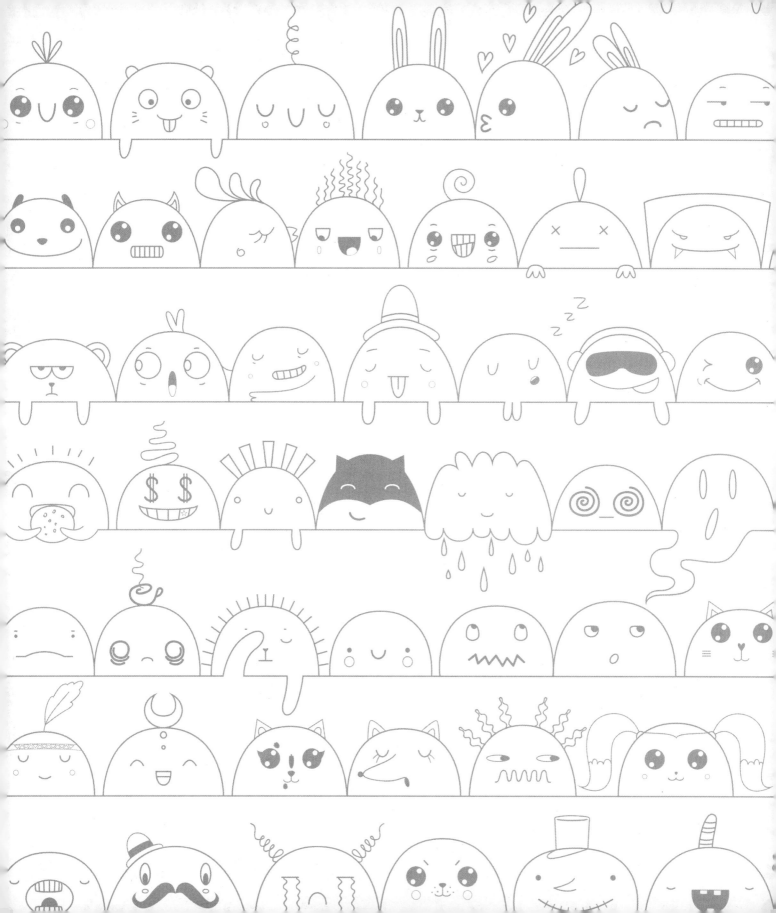

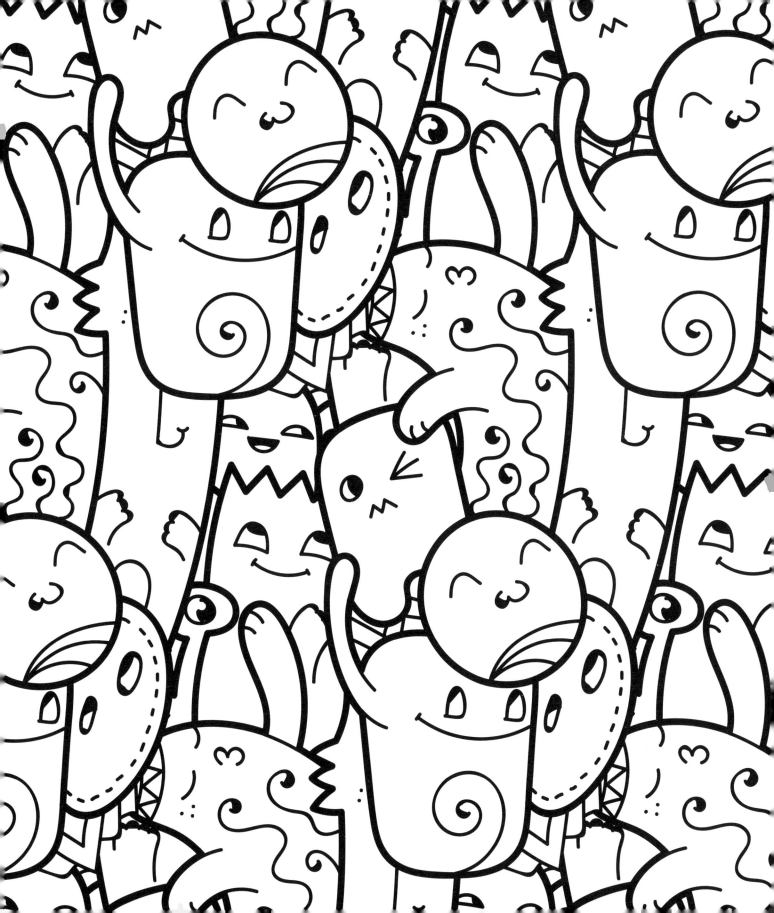

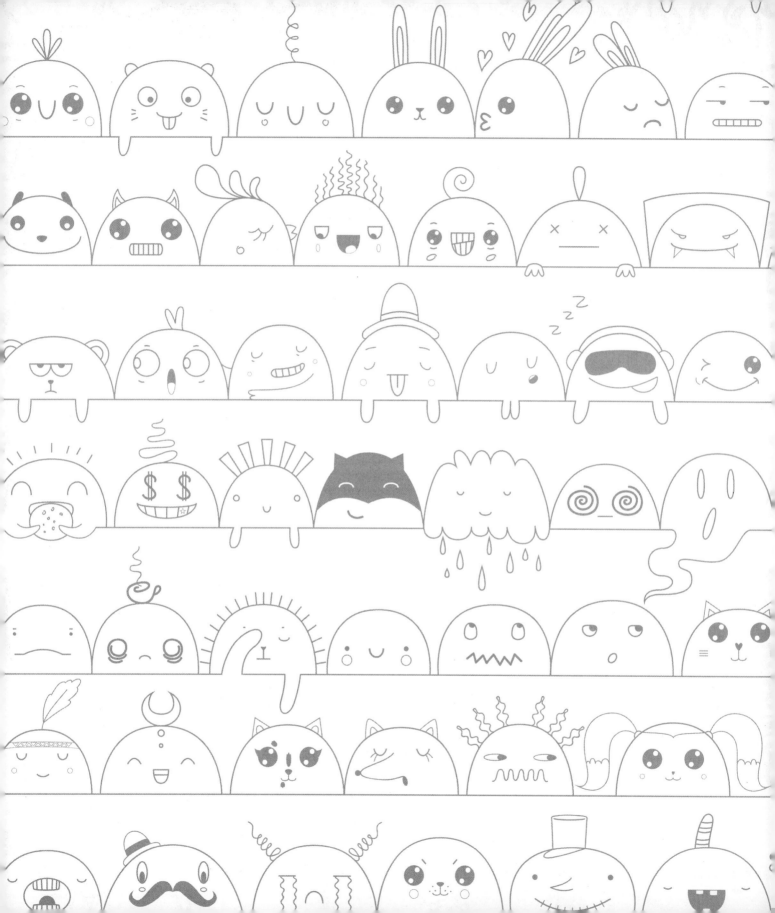

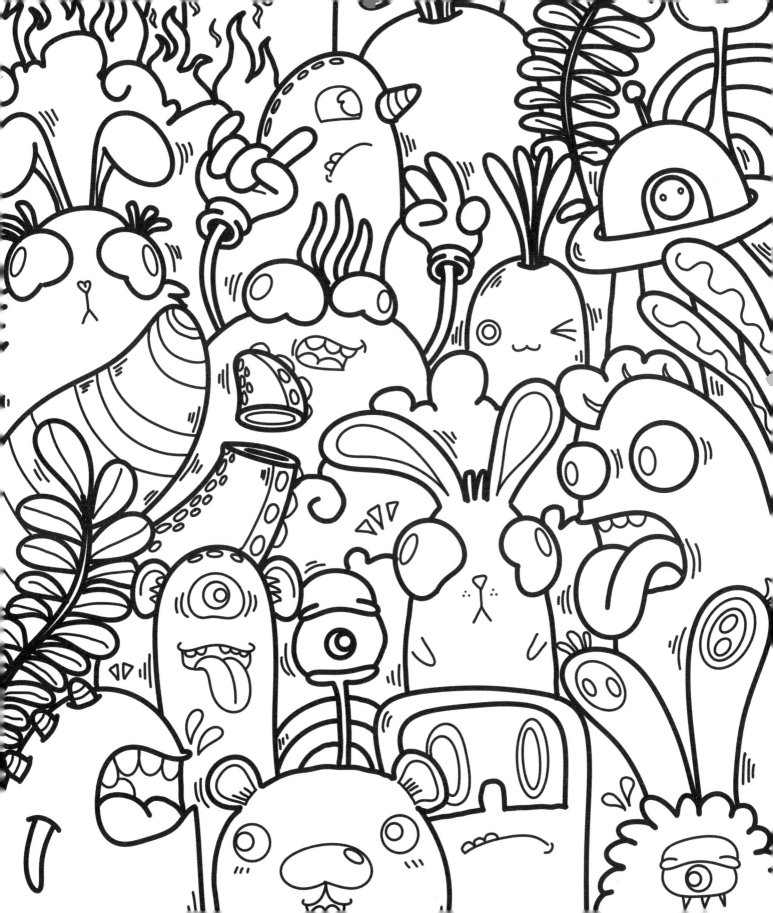

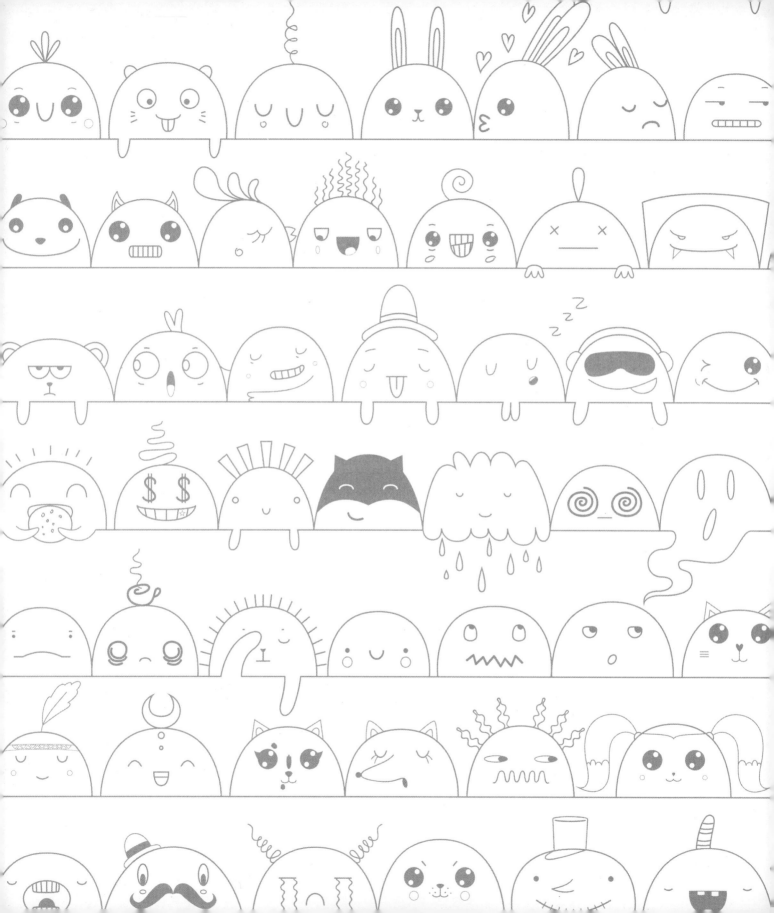

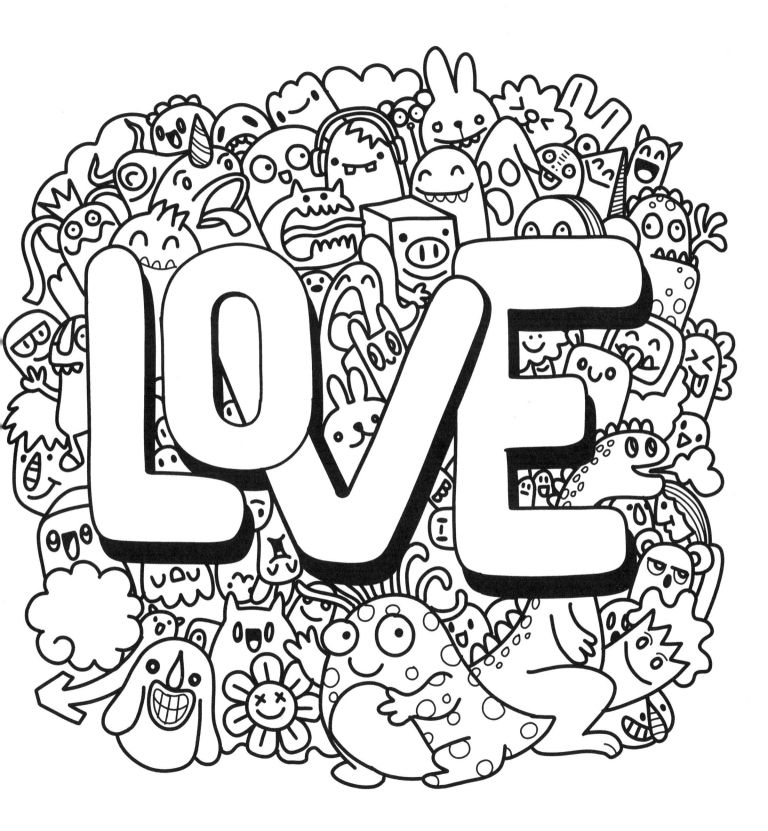

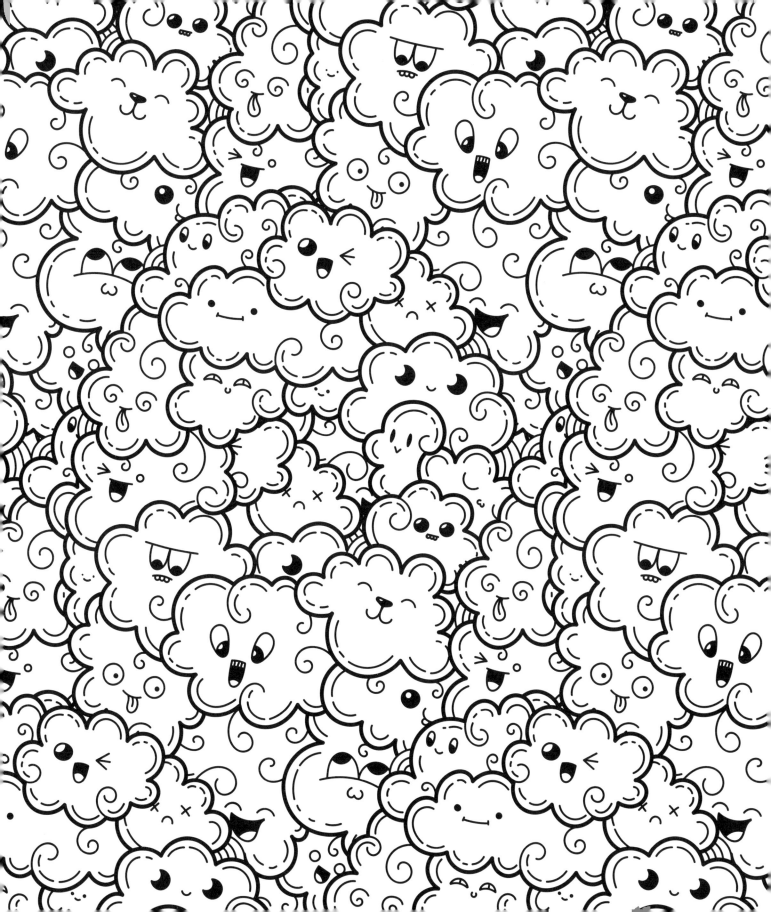

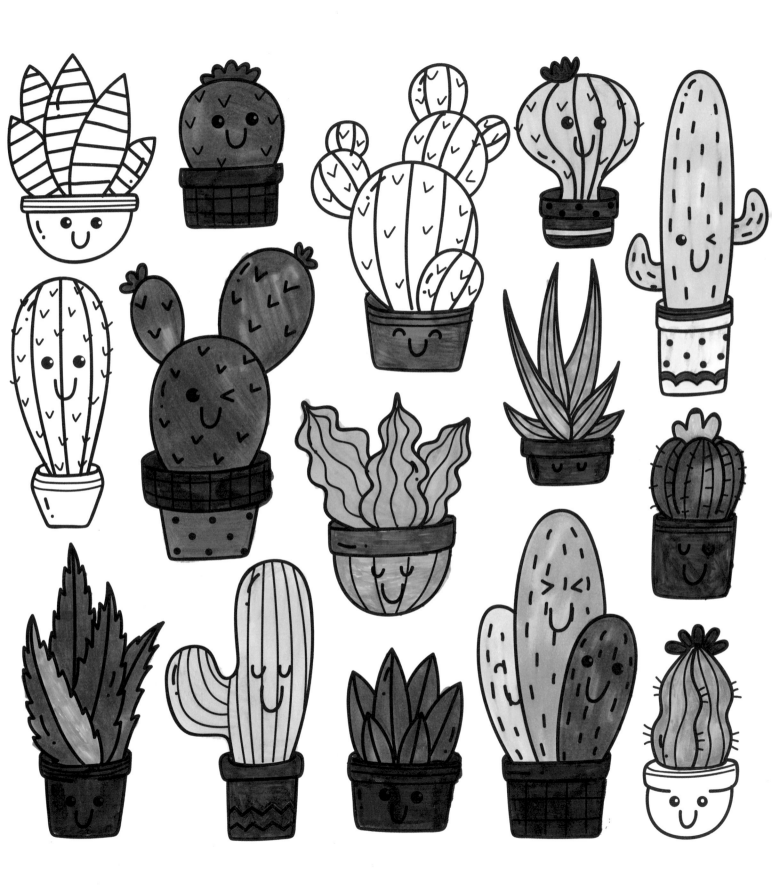

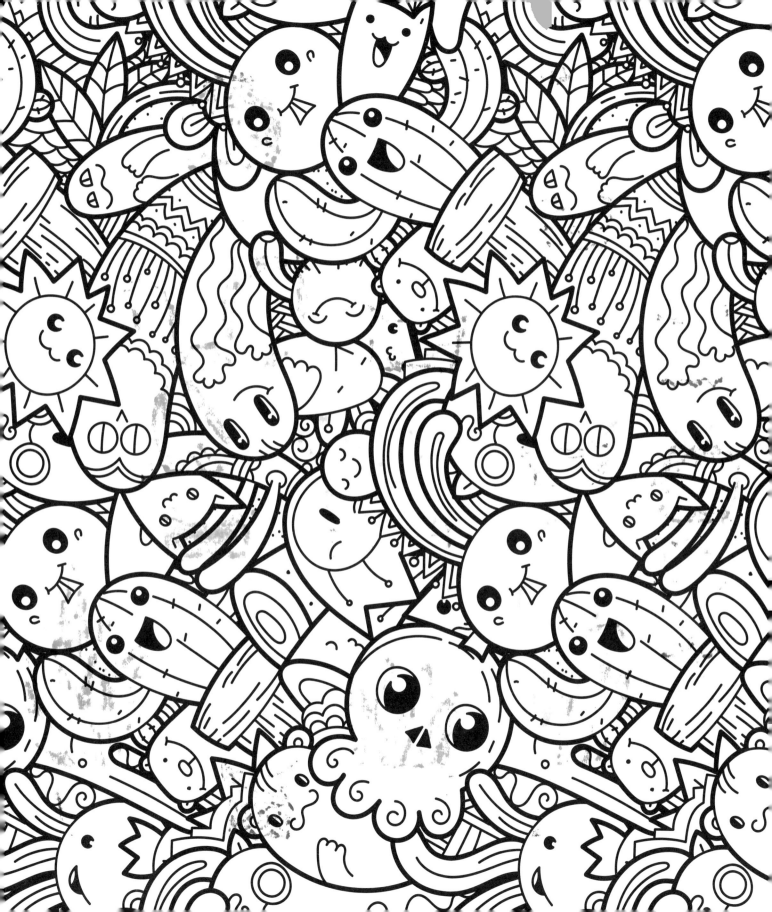

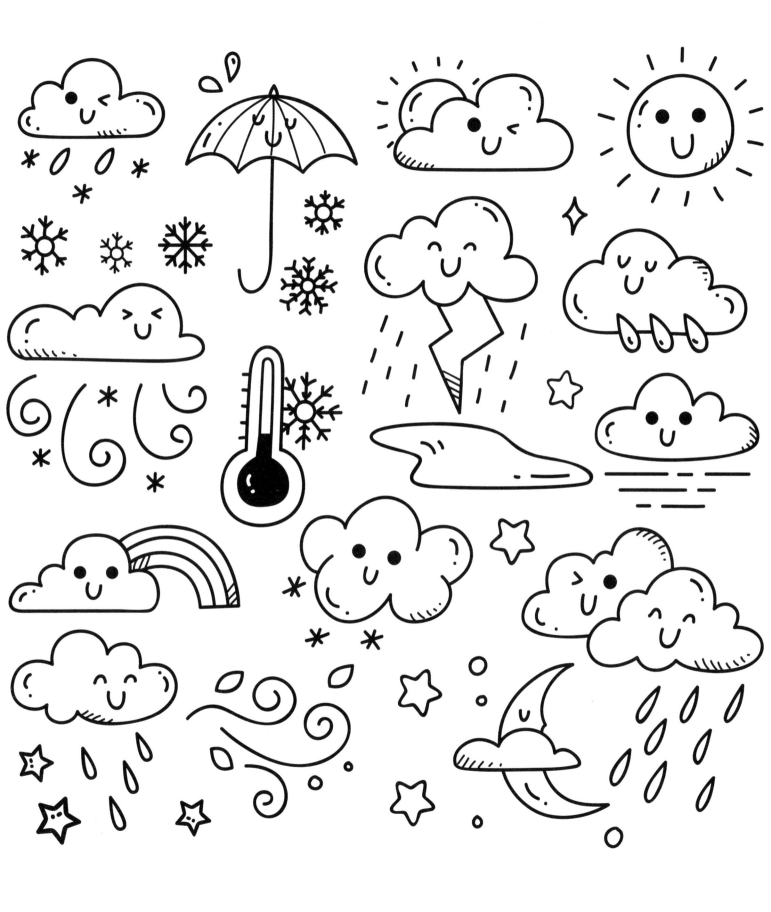

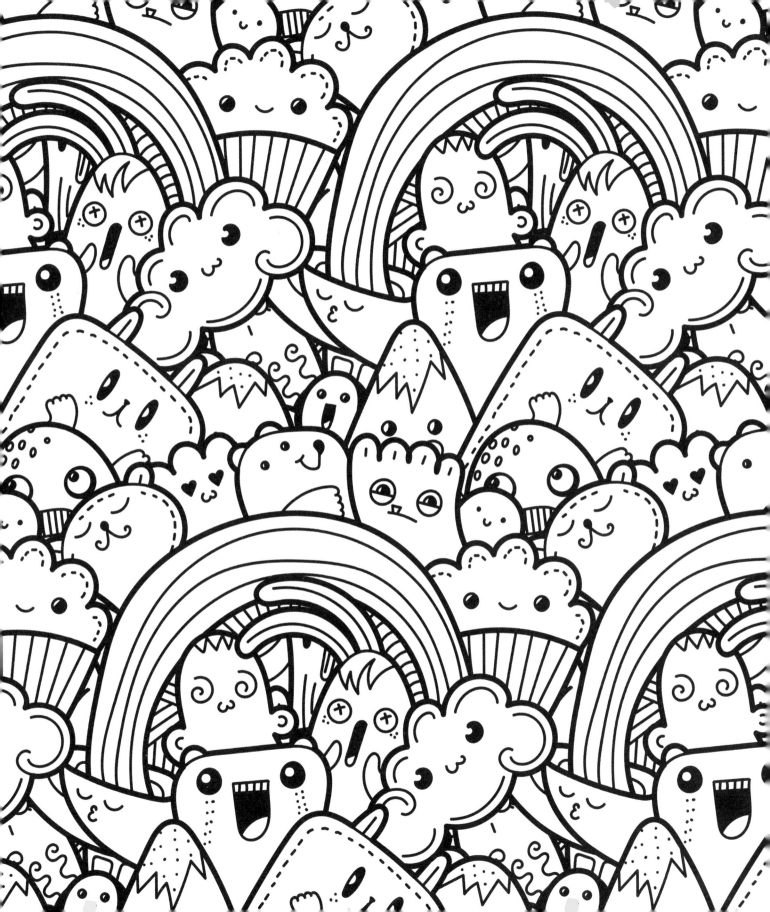

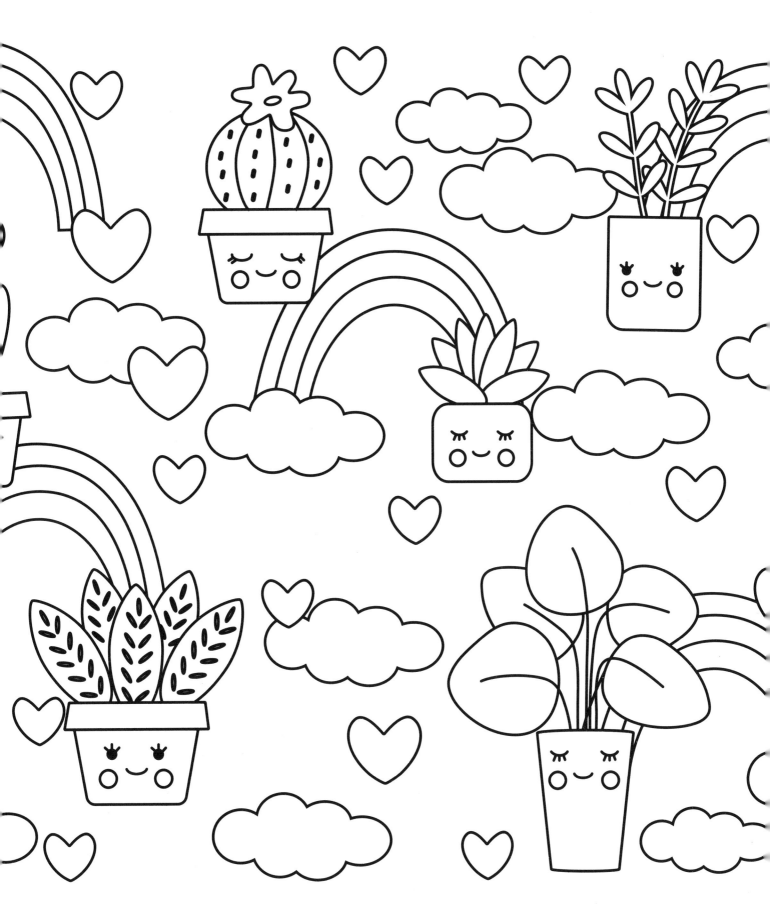

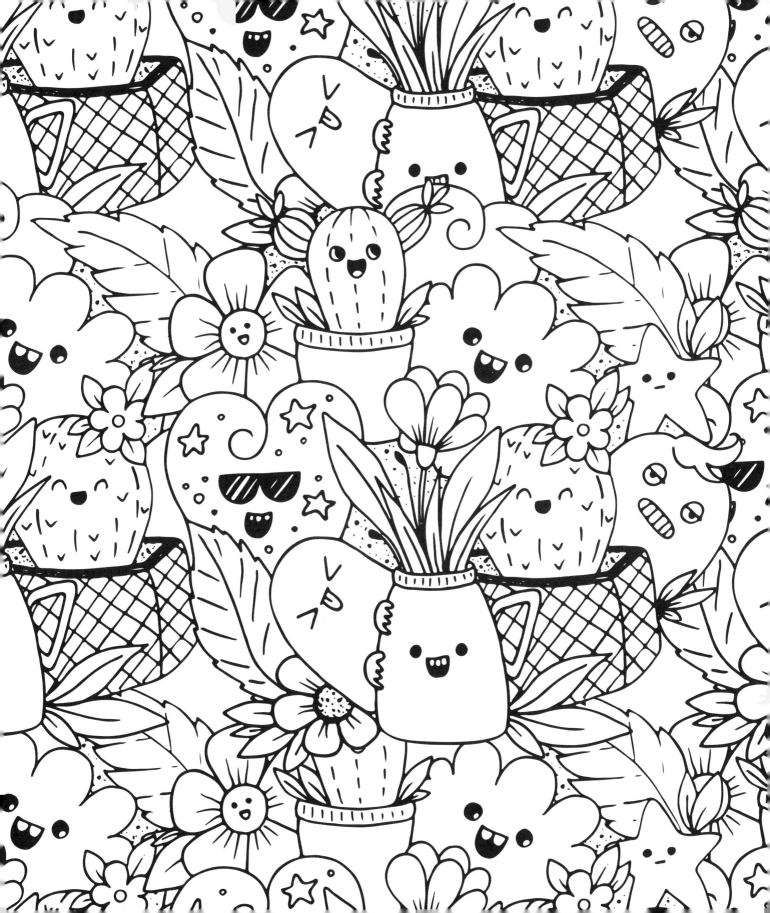

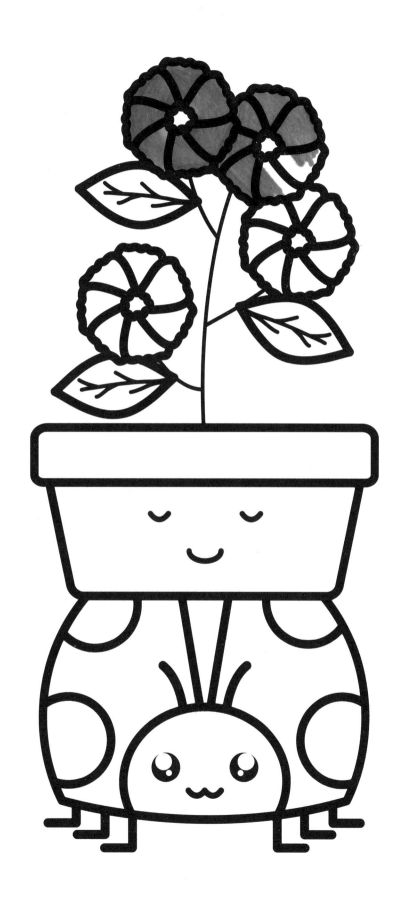

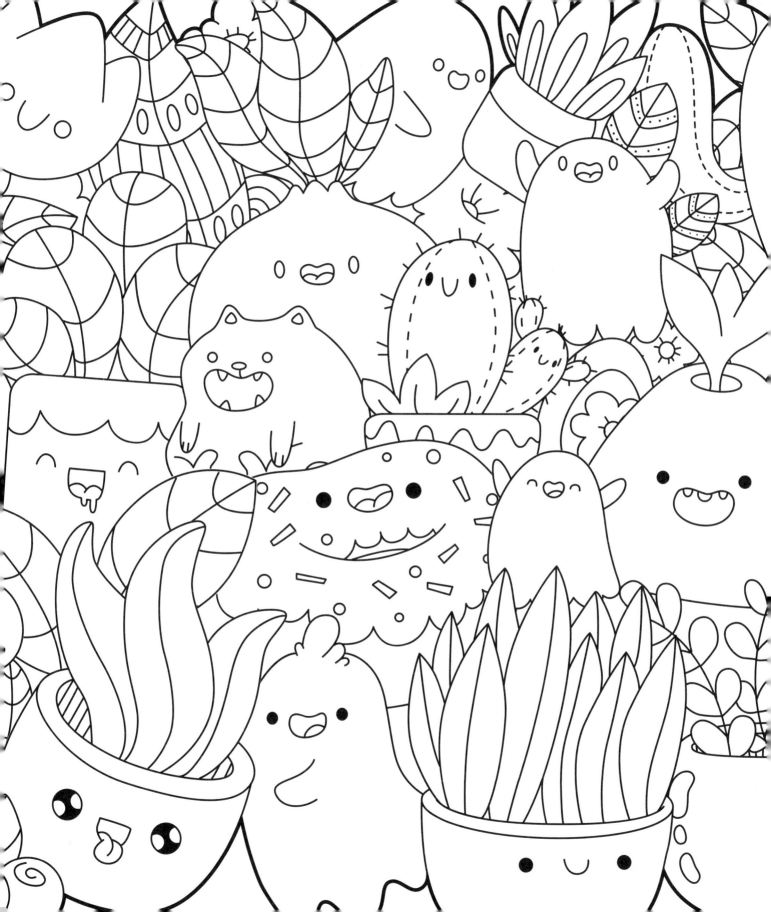

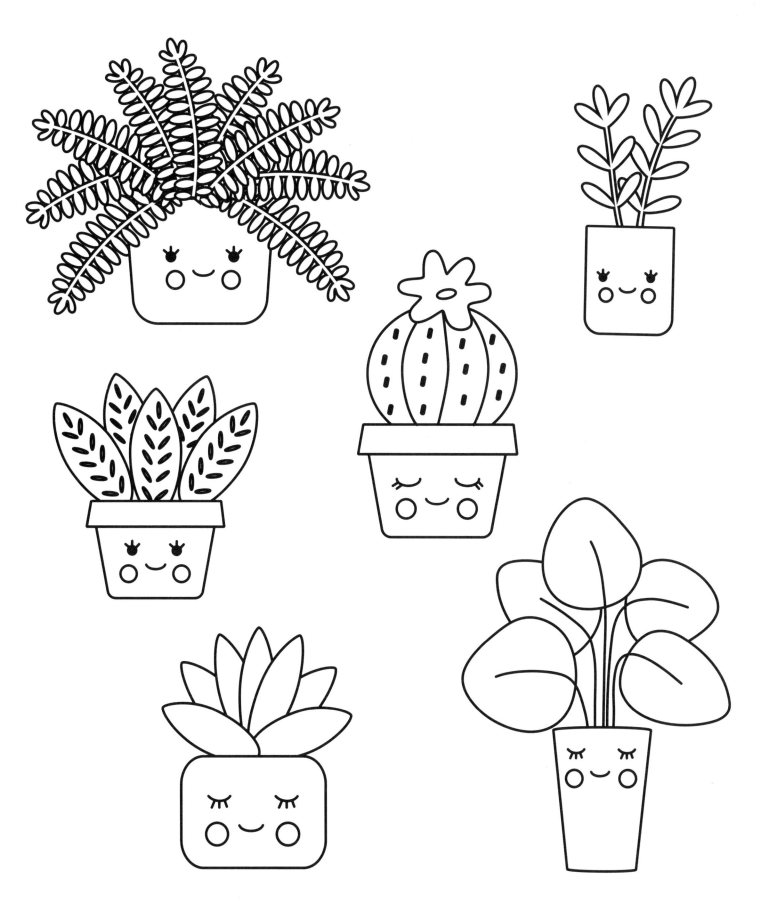

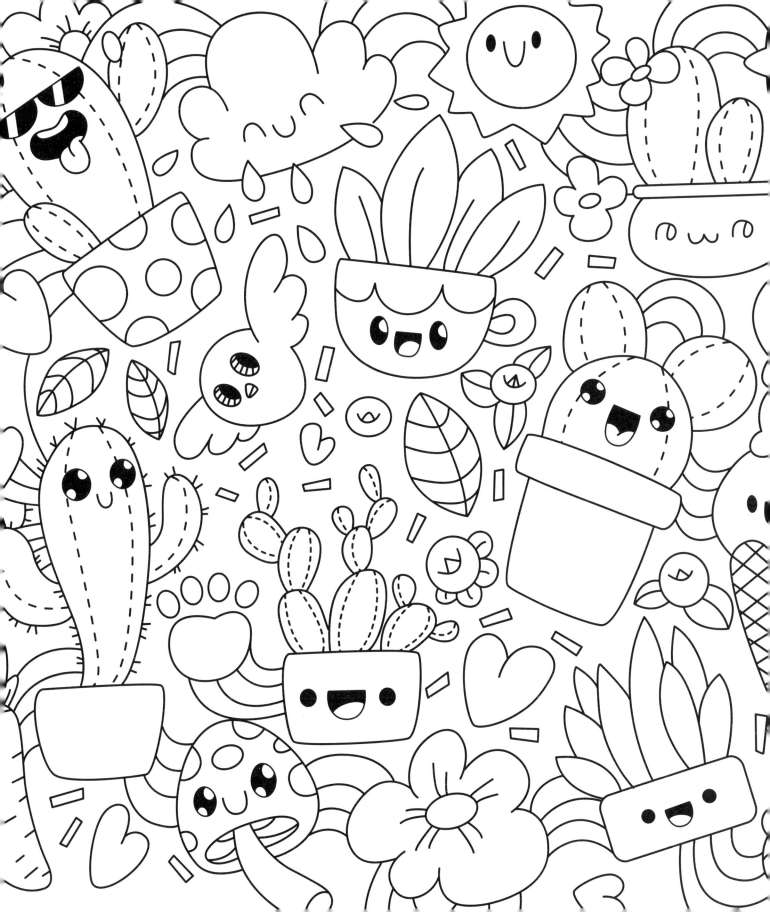

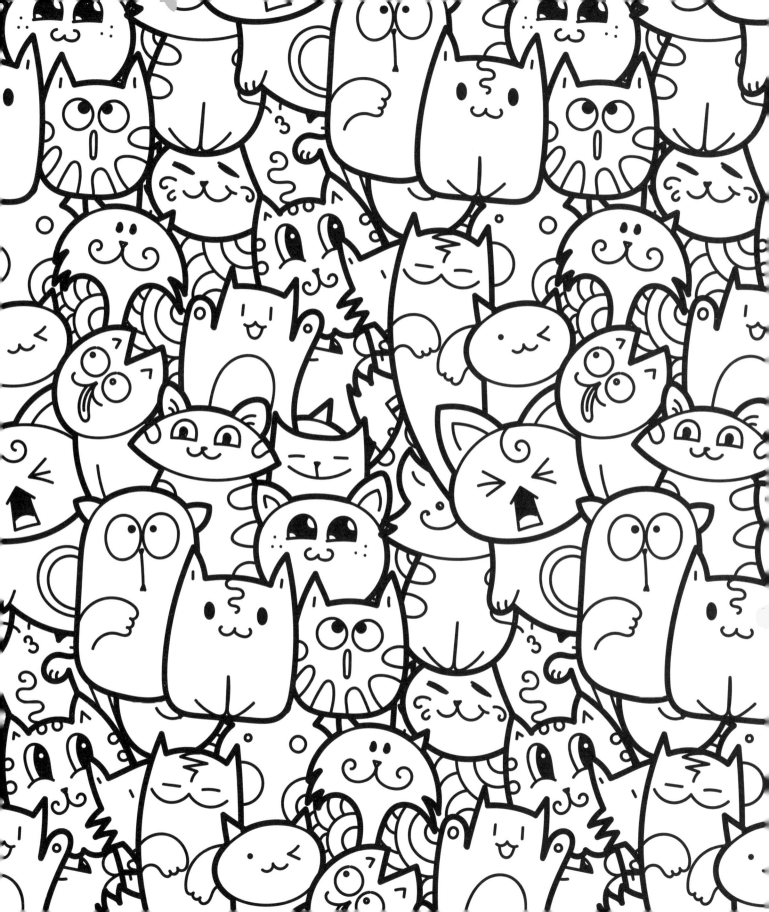

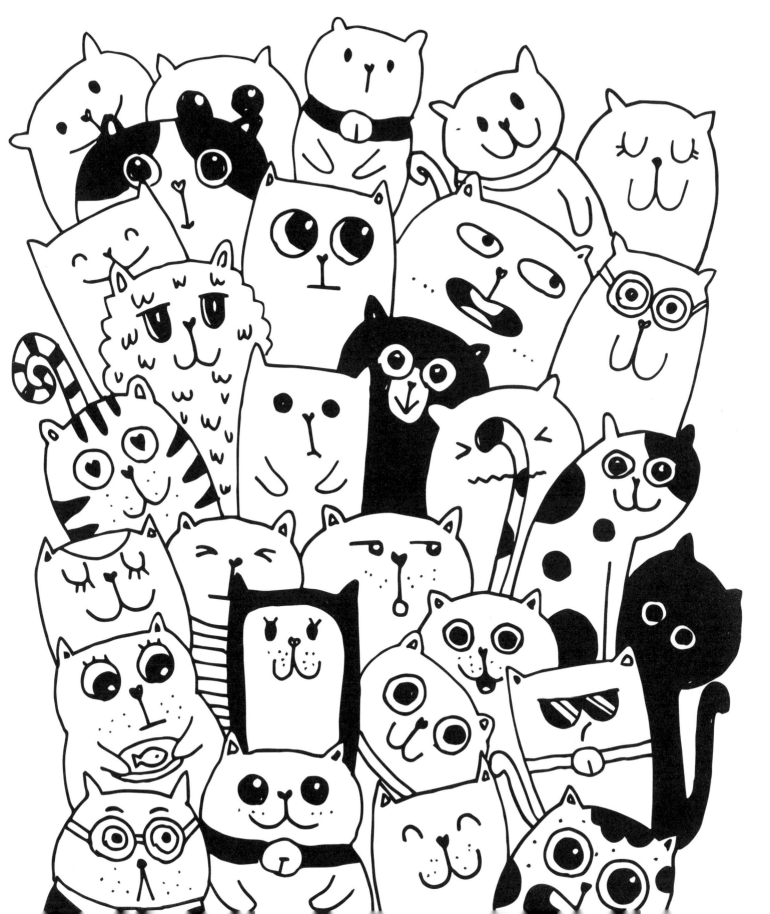

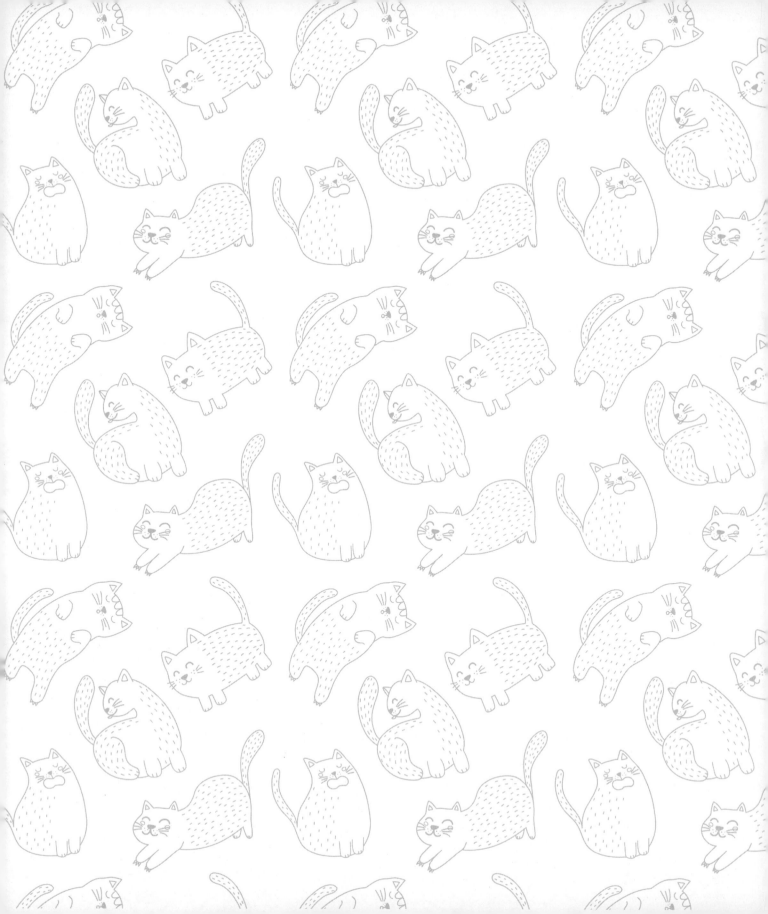

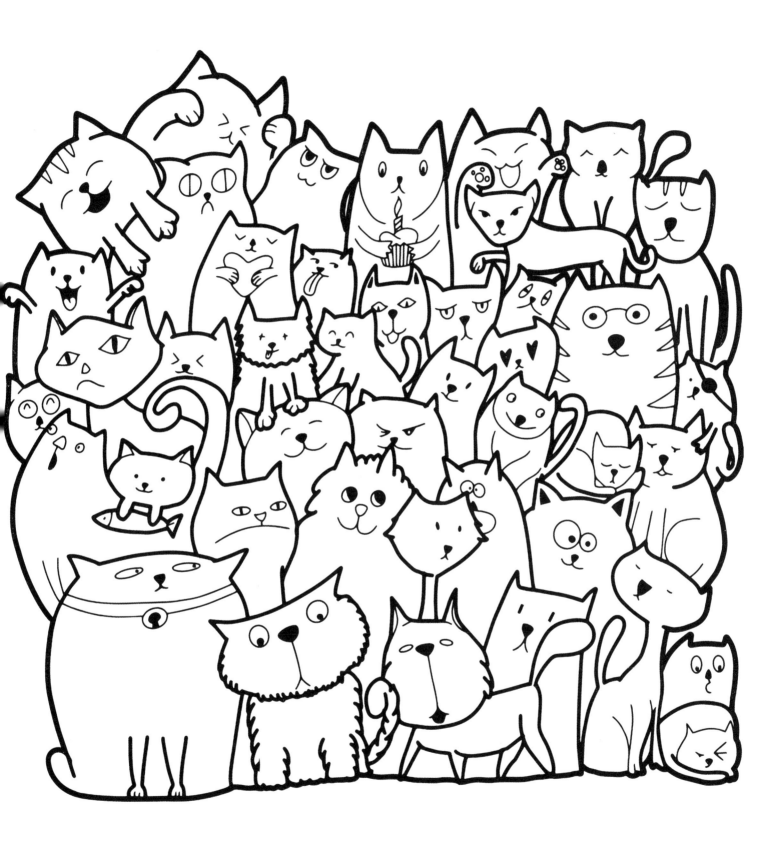

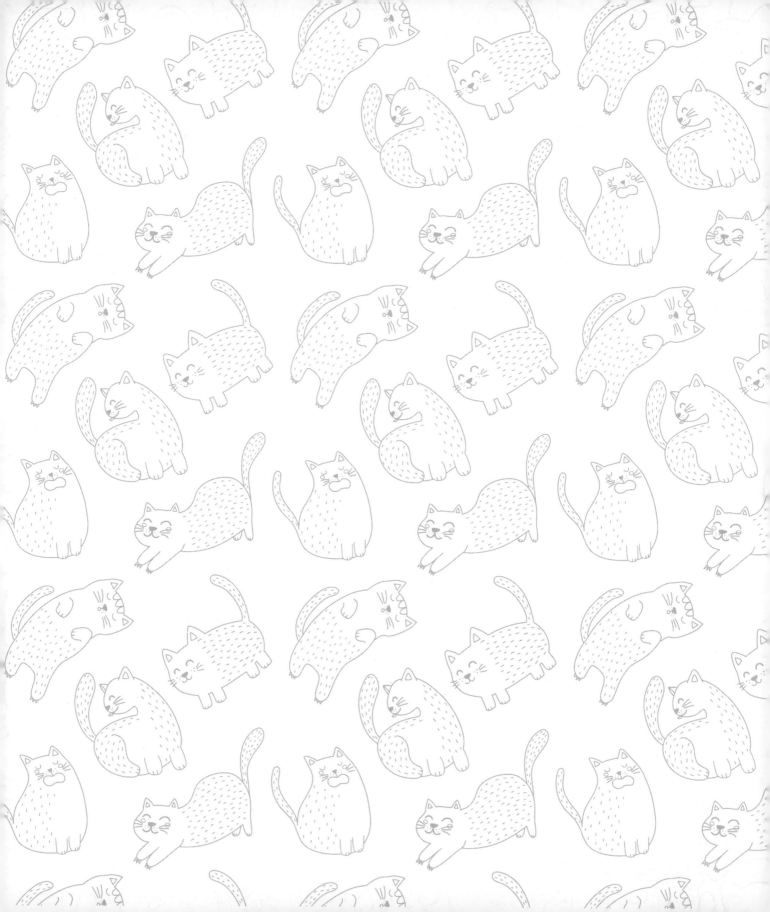

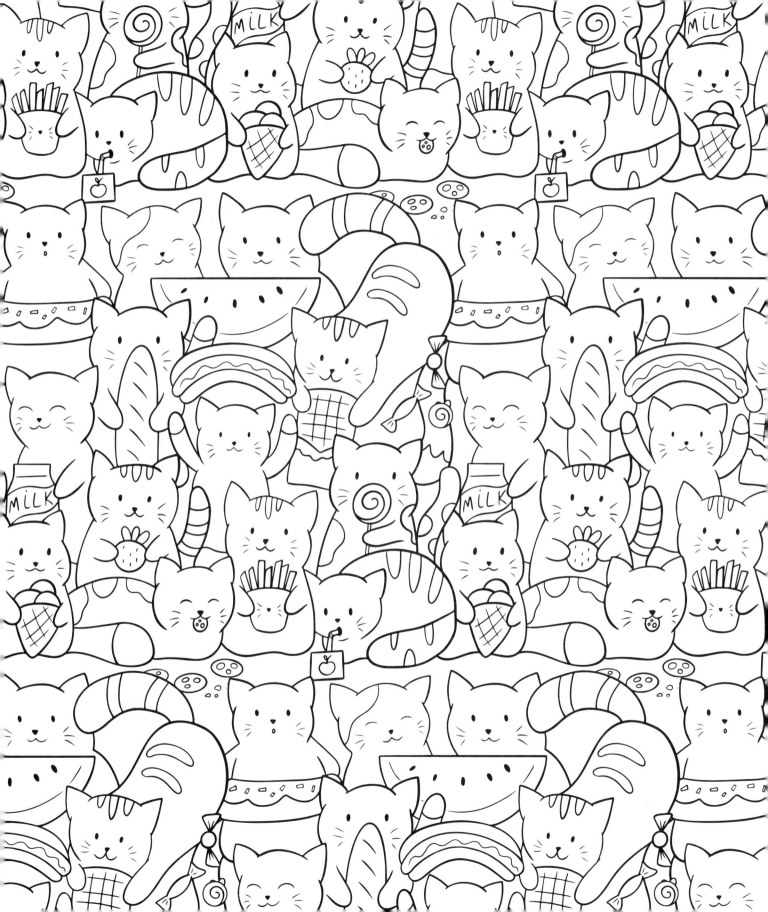

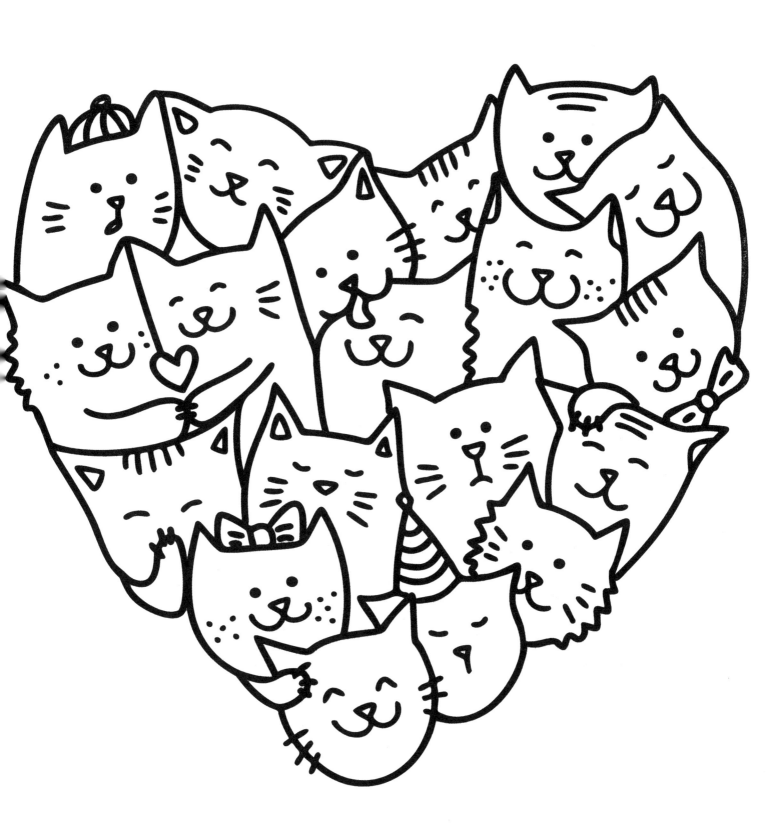

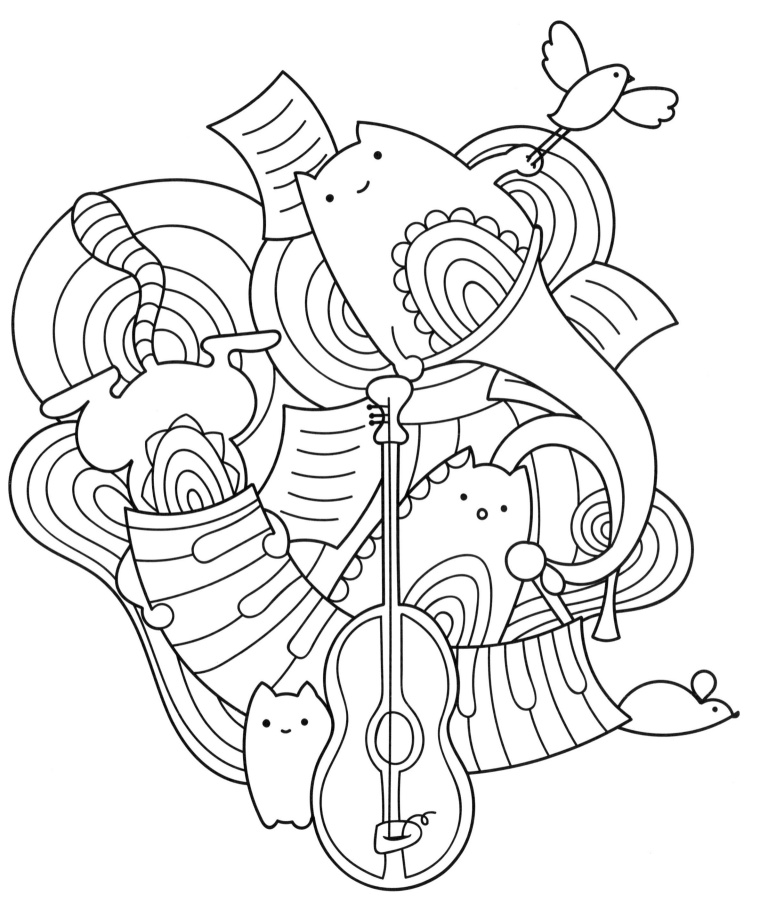

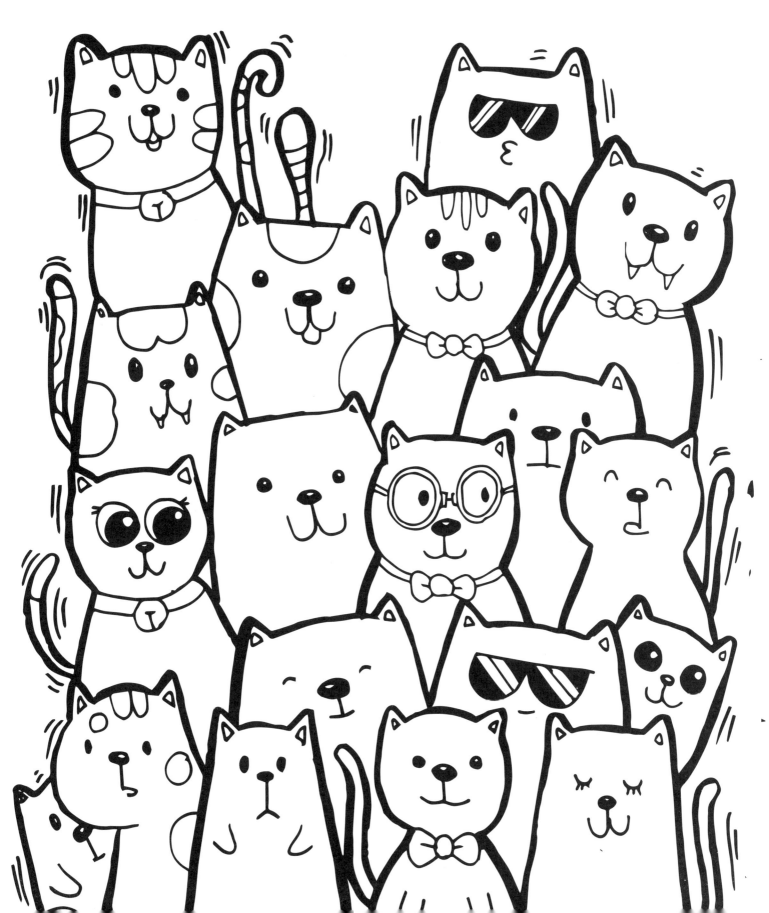

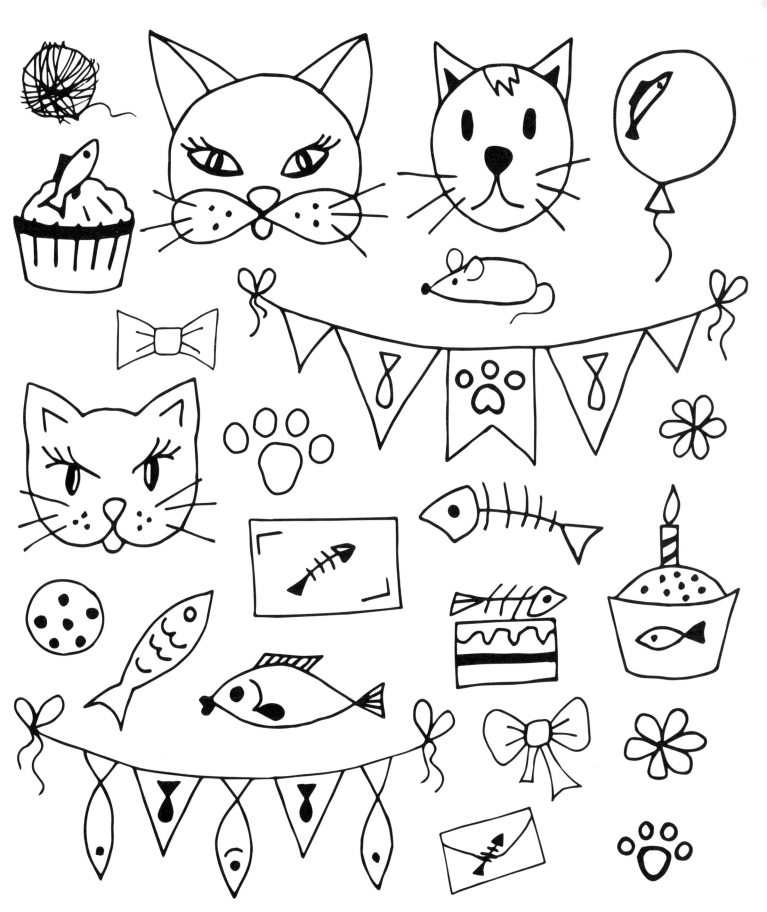

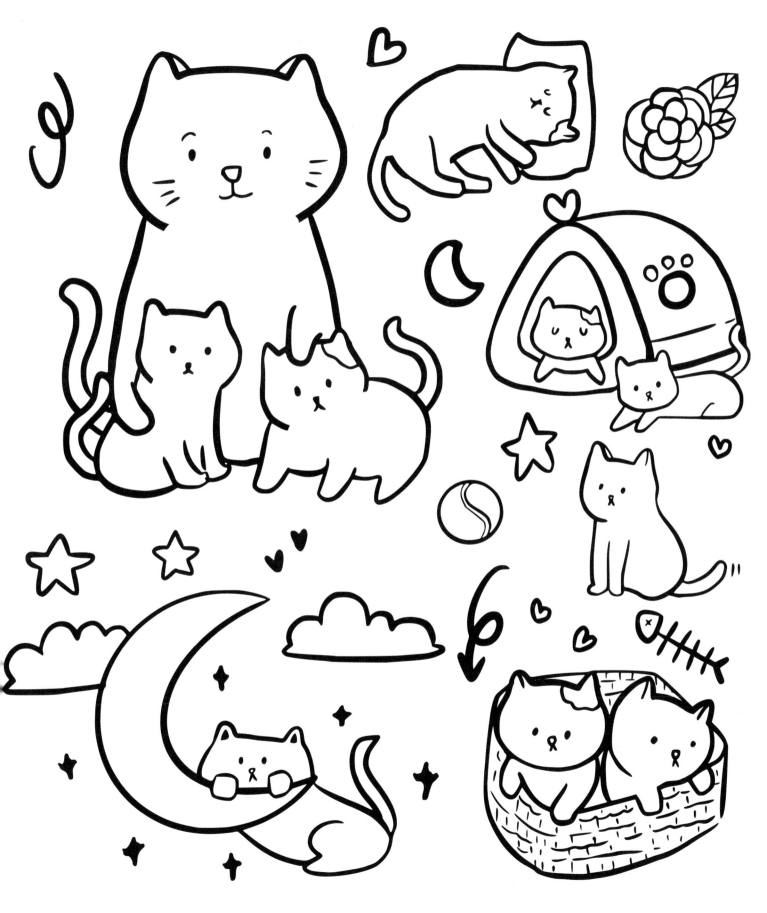

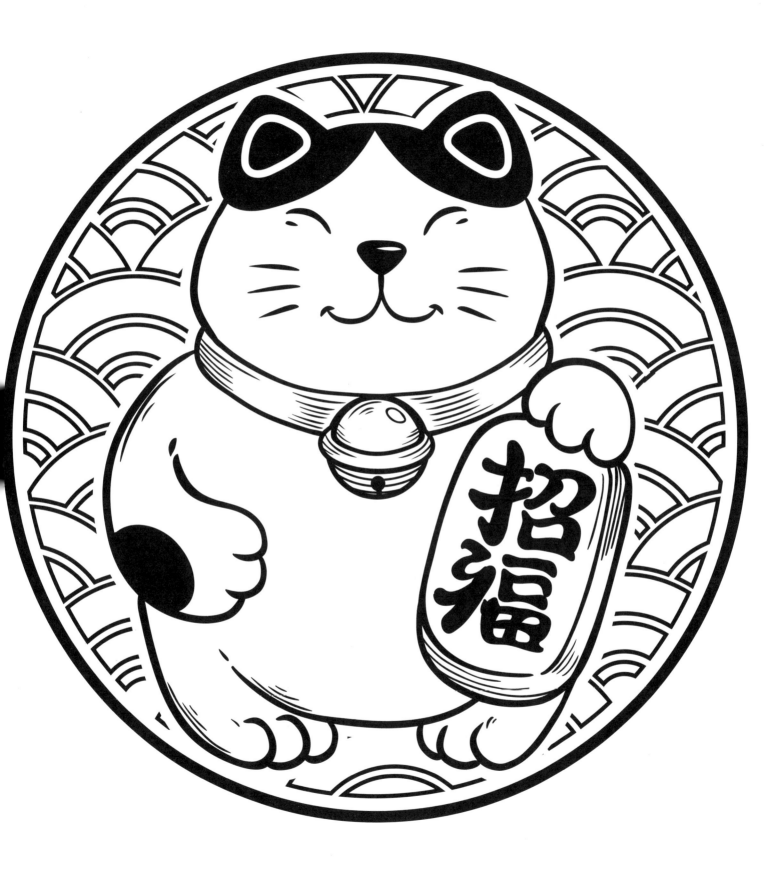

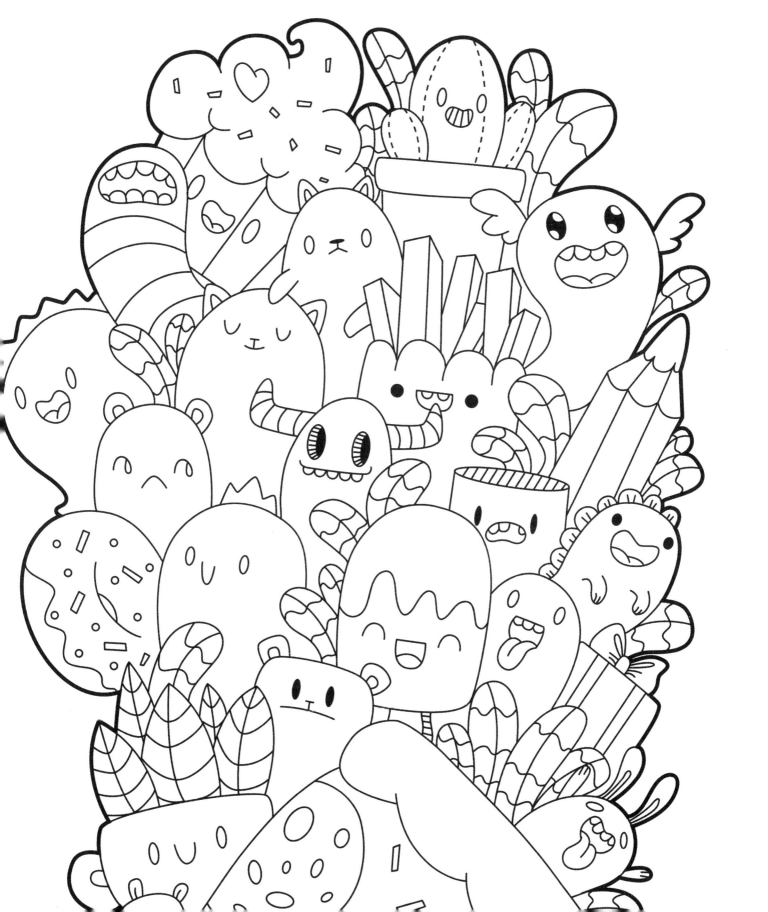

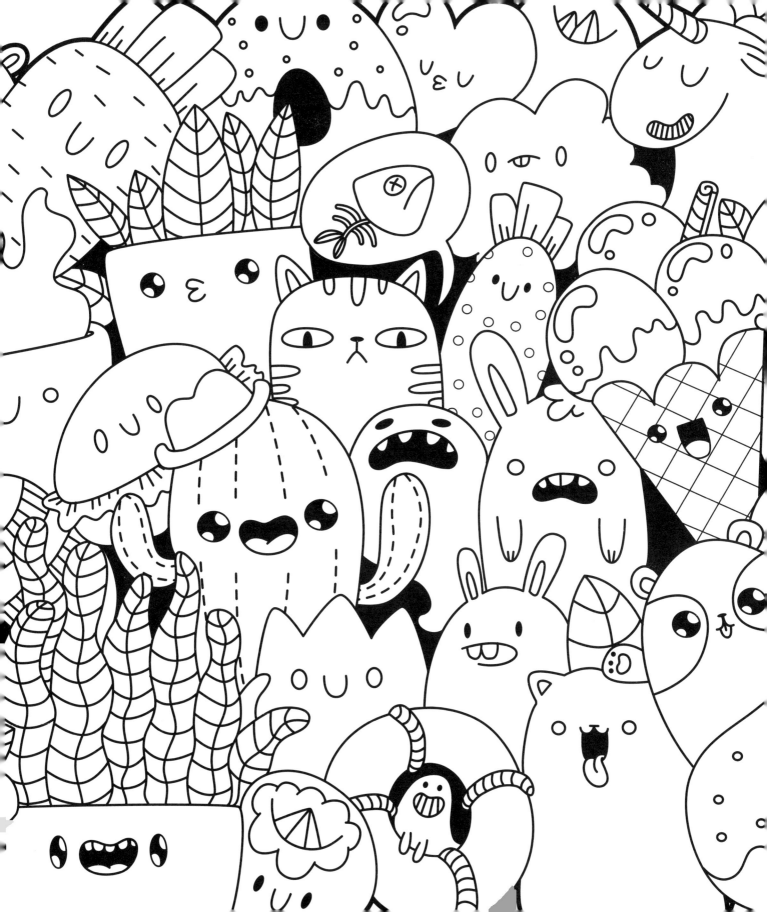

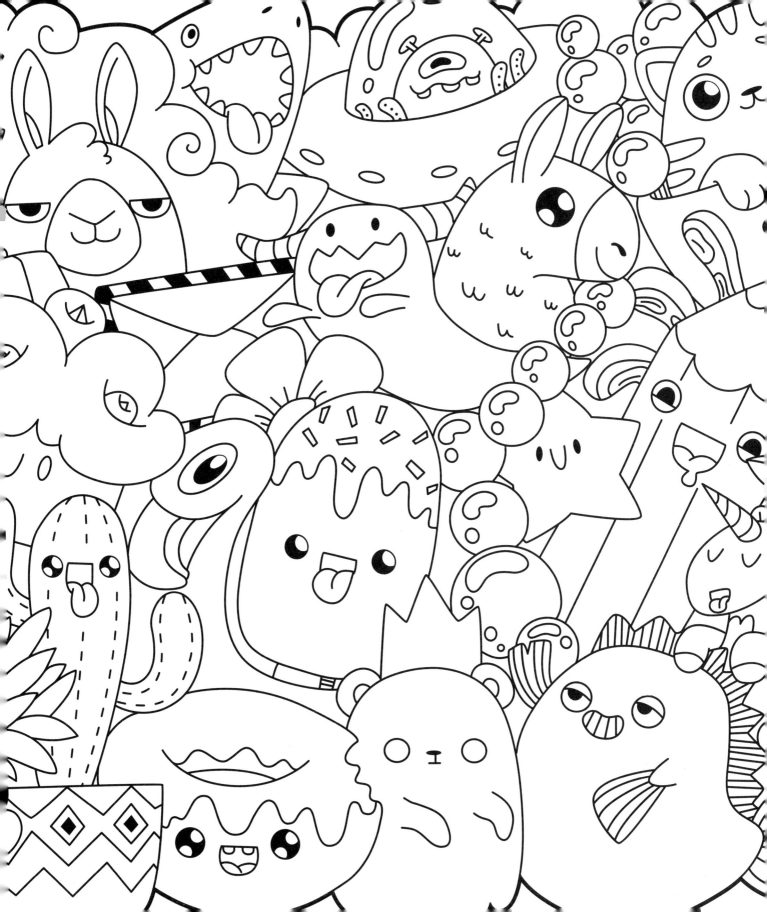

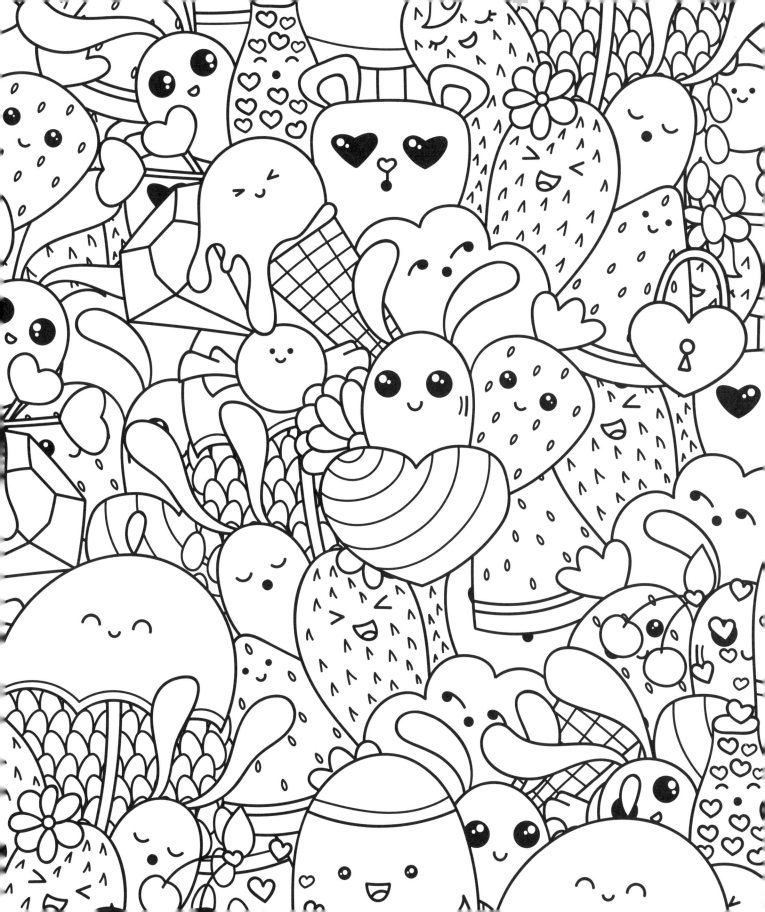

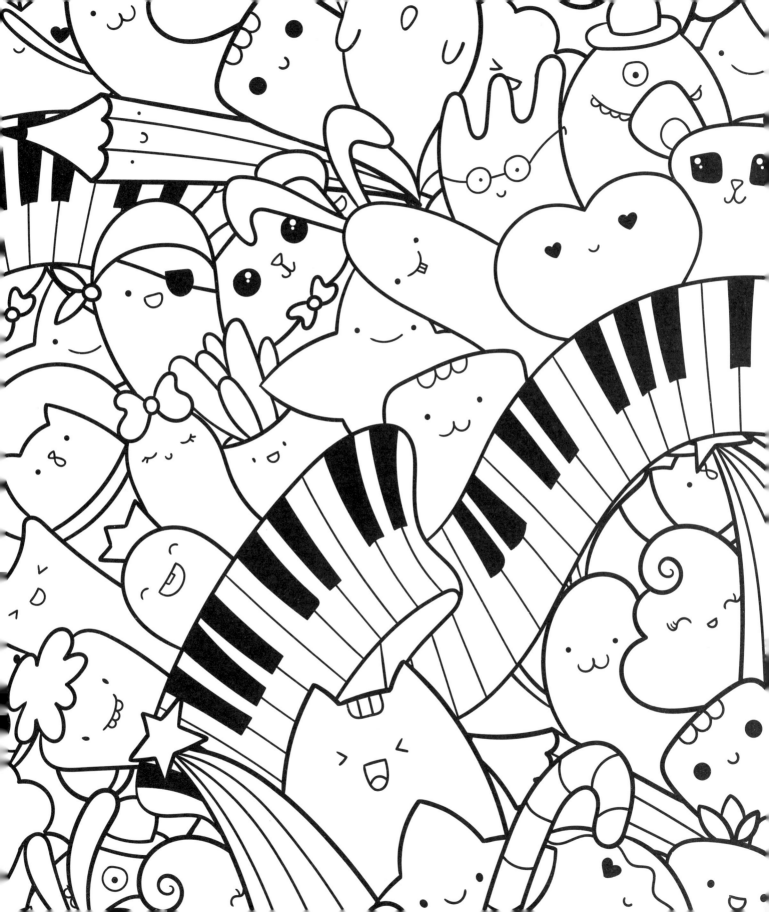

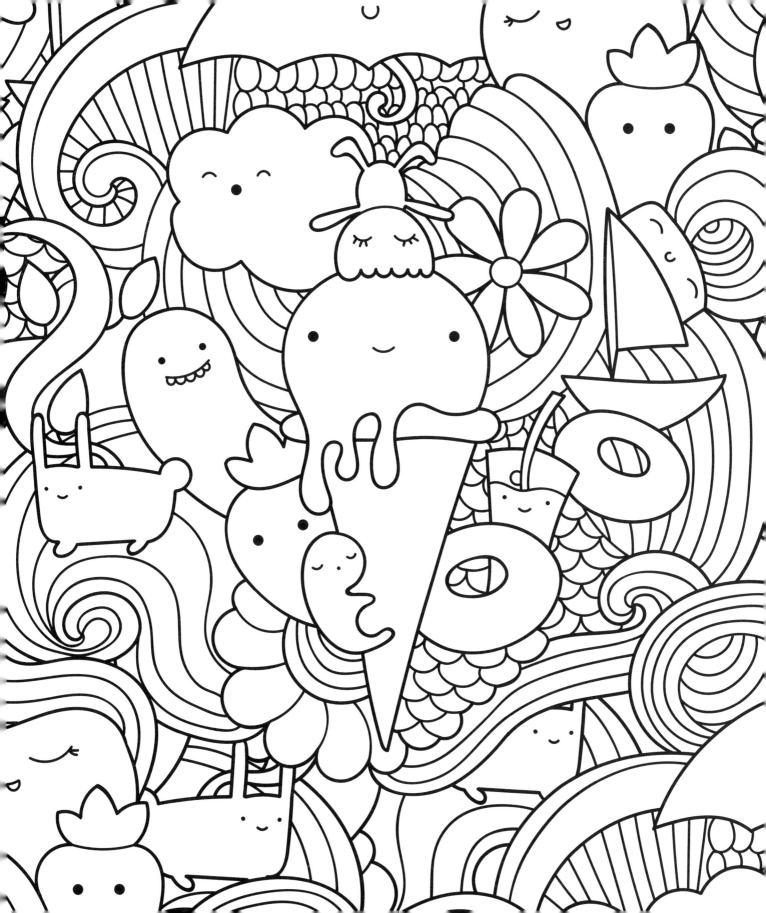

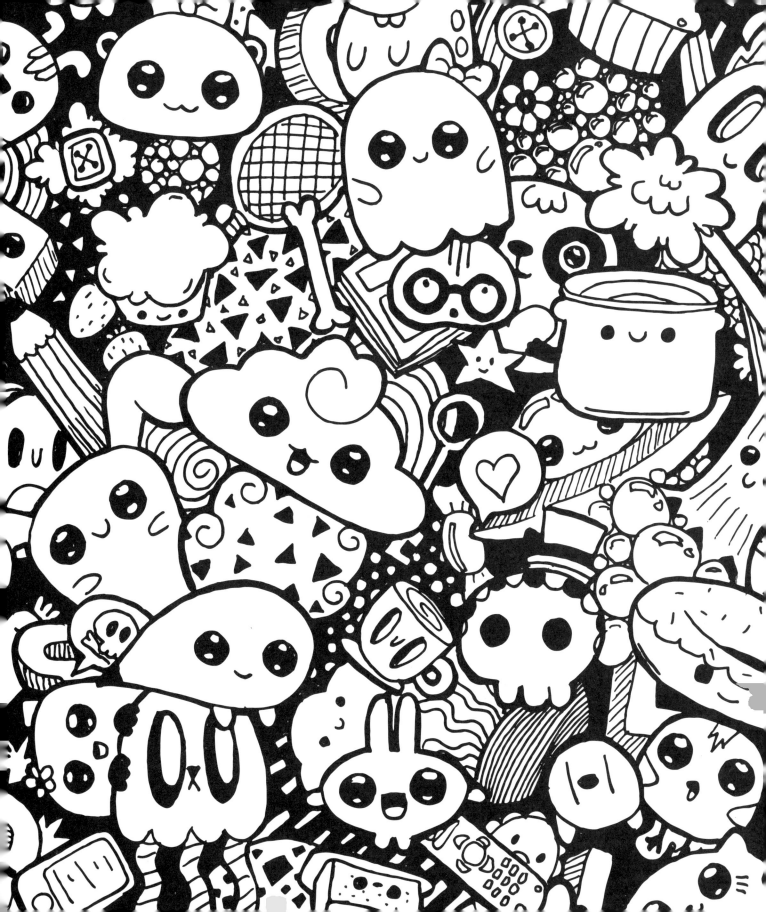

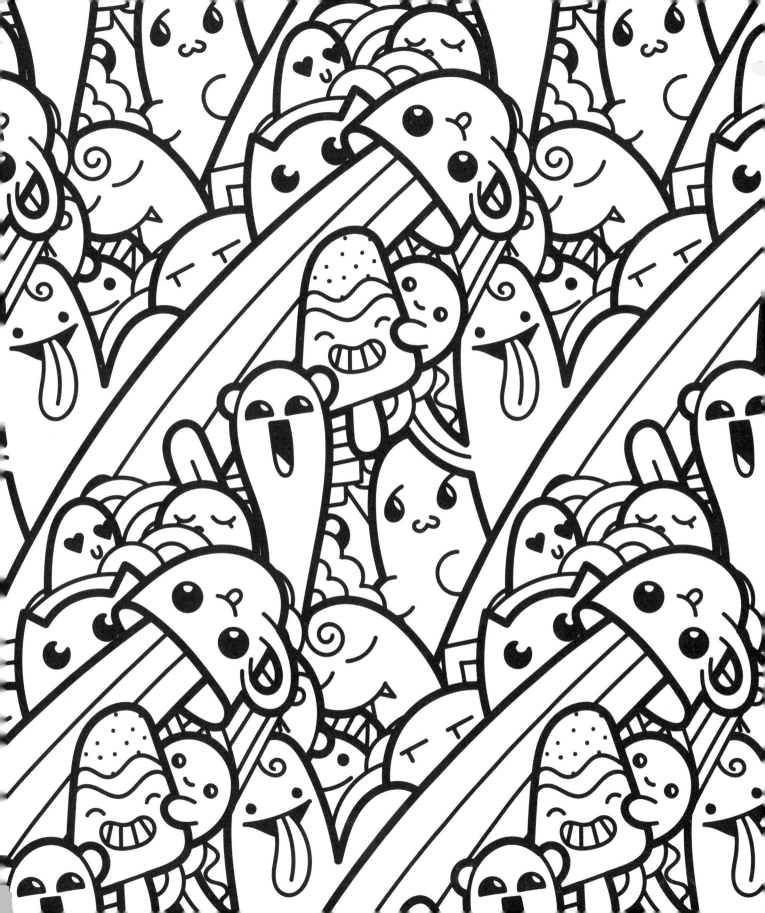

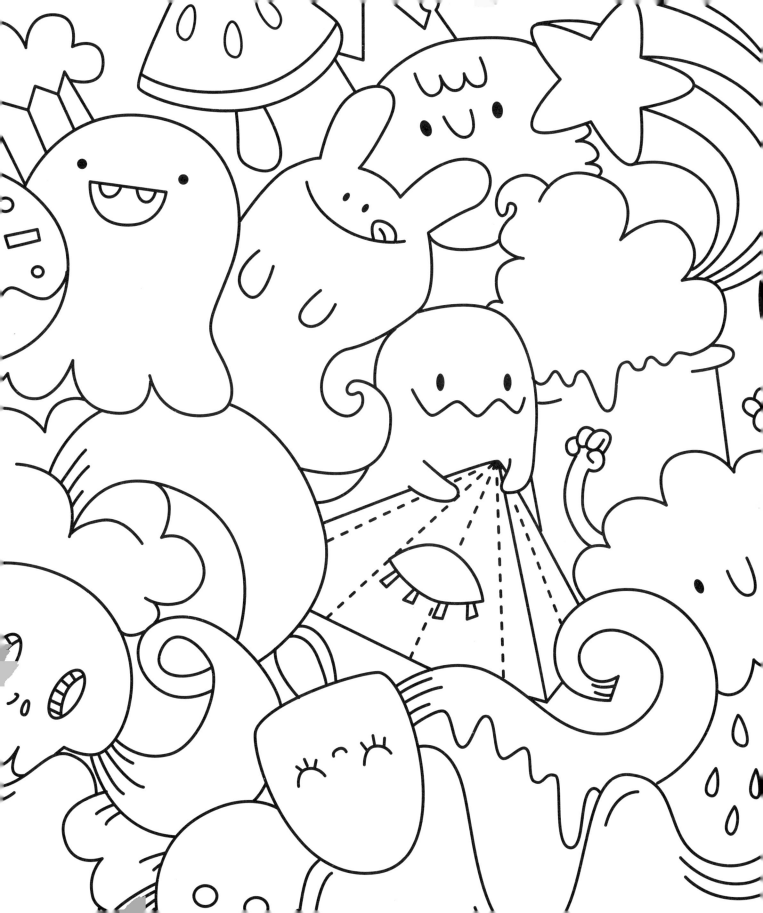

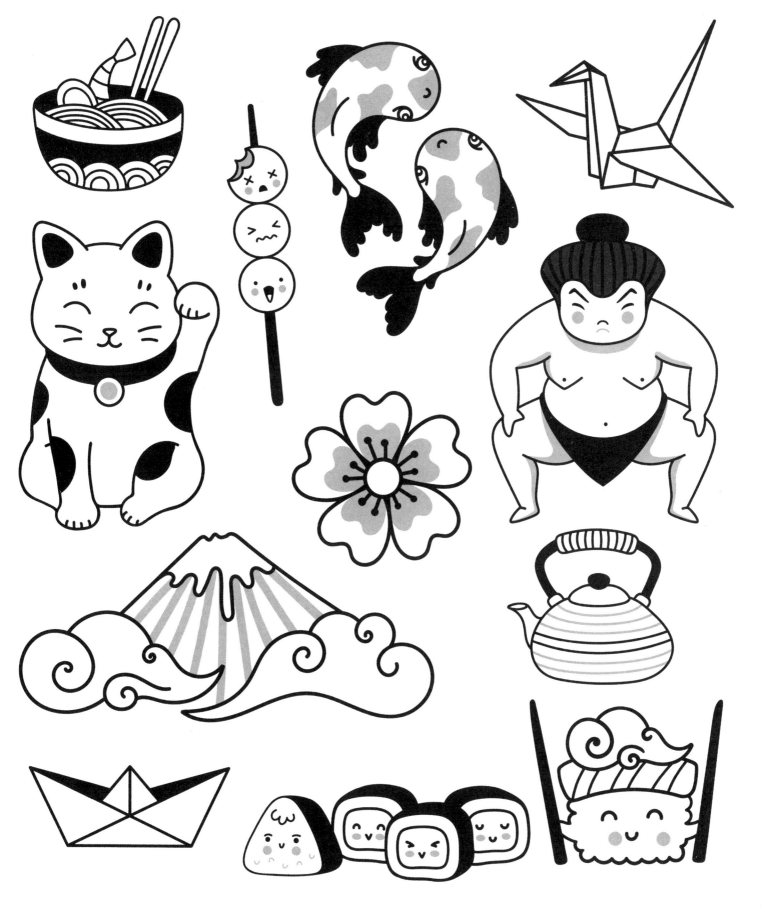

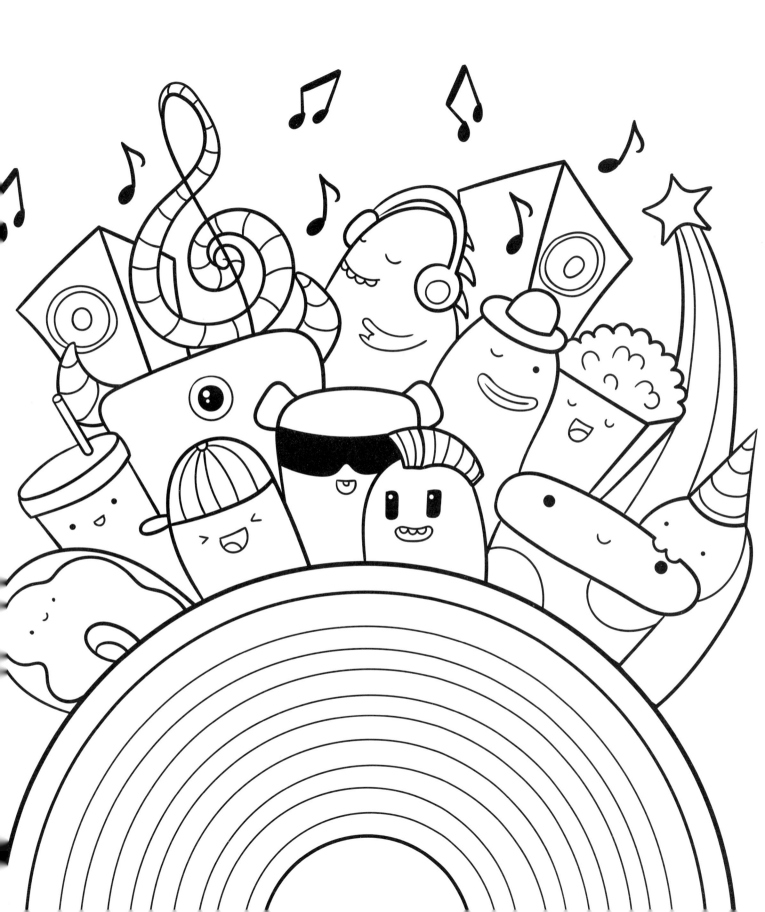

Inspiring | Educating | Creating | Entertaining

Brimming with creative inspiration, how-to projects, and useful information to enrich your everyday life, quarto.com is a favorite destination for those pursuing their interests and passions.

First published in 2021 by Chartwell Books,
an imprint of The Quarto Group
142 West 36th Street, 4th Floor
New York, NY 10018 USA
T (212) 779-4972 F (212) 779-6058
www.Quarto.com

10 9 8 7

Chartwell titles are also available at discount for retail, wholesale, promotional, and bulk purchase. For details, contact the Special Sales Manager by email at specialsales@quarto.com or by mail at The Quarto Group, Attn: Special Sales Manager, 100 Cummings Center Suite 265D, Beverly, MA 01915, USA.

ISBN: 978-0-7858-3937-8

Publisher: Rage Kindelsperger
Creative Director: Laura Drew
Managing Editor: Cara Donaldson
Editorial Assistant: Alma Gomez Martinez
Cover Design: Laura Drew
Interior Design: James Kegley

Printed in China